IMAGES
of America

ROUTE 128 AND THE BIRTH OF THE AGE OF HIGH TECH

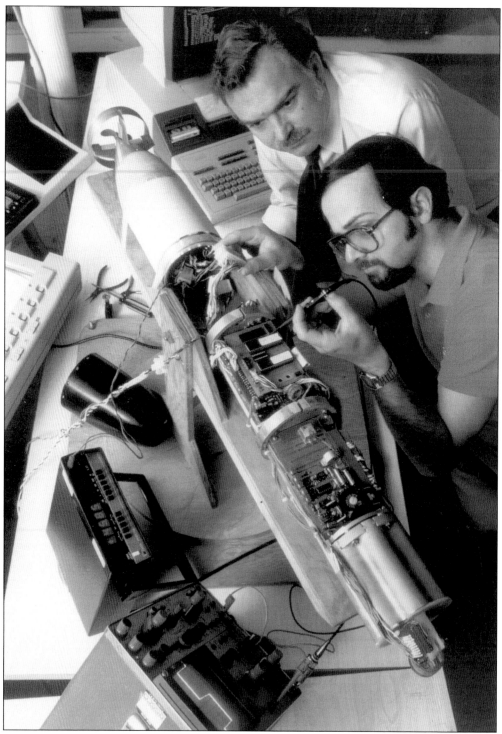

Sippican Ocean Systems developed and produced sensing devices that could be launched from airplanes, submarines, or ships. It was another example of the 128 region's technical diversity and fertility. (Courtesy *Mass High Tech*.)

IMAGES
of America

ROUTE 128 AND THE BIRTH OF THE AGE OF HIGH TECH

Alan R. Earls

ARCADIA
PUBLISHING

Published by Arcadia Publishing
Charleston, South Carolina

Printed in the United States of America

Library of Congress Catalog Card Number: 2002108399

For all general information contact Arcadia Publishing at:
Telephone 843-853-2070
Fax 843-853-0044
E-Mail sales@arcadiapublishing.com
For customer service and orders:
Toll-Free 1-888-313-2665

Visit us on the Internet at www.arcadiapublishing.com

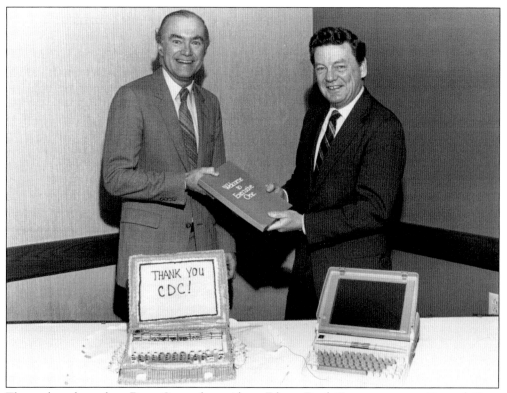

That takes the cake—Data General president Edson D. deCastro presents Control Data Corporation (CDC) president and chief operating officer Robert M. Price with a Data General/ One and accompanying "Executive One Service" in honor of CDC's 1,000th order, an Eclipse MV/4000 minicomputer. The occasion was celebrated with a life-sized cake in the image of the Data General/One laptop computer, as seen in this 1980s photograph. Data General was one of the stars of the Massachusetts Miracle years. (Courtesy *Mass High Tech*.)

CONTENTS

ACKNOWLEDGMENTS

I am grateful for the help and assistance of many individuals and organizations. In particular, thanks go to Dyke Hendrickson at *Mass High Tech* newspaper; Norman Krim at Raytheon; Ann Jenkins at Advanced Modular Solutions; Jane Stoy at the Massachusetts High Technology Council; Alan M. Shoemaker at MITRE; Michael Panagako at Nordblom; Douglas Cope at the Massachusetts Highway Department; Teradyne Inc.; the staff of the Massachusetts Archive; the staff of the Boston Public Library; John Wood; Philip Lichtman; Jonathan Rotenberg; Deanna Michaelson; my wife, Karen McCarthy, who took many of the photographs included here; the Historical Office at Hanscom Air Base; and many others.

Other sources of information for this book included my personal archives, *Mass High Tech* newspaper; *Teradyne: The First Forty Years,* by Frederick Van Veen; *Digital at Work,* edited by Jamie Parker Pearson; *The Ultimate Entrepreneur: The Story of Ken Olsen and Digital Equipment Corporation,* by Glenn Rifkin and George Harrar; *The Creative Ordeal: The Story of Raytheon,* by Otto J. Scott; *Journey to the Moon: The History of the Apollo Guidance Computer,* by Eldon C. Hall; *Land's Polaroid: A Company and the Man Who Invented It,* by Peter C. Wensberg; *Regional Advantage: Culture and Competition in Silicon Valley and Route 128,* by AnnaLee Saxenian; *The Massachusetts Miracle,* edited by David Lampe; *Lessons: An Autobiography,* by Dr. An Wang with Eugene Linden; *Massachusetts Route 128: A Non-Emulative Enigma,* by Dr. Don Levitan of Suffolk University; and *MITRE: The First Twenty Years.*

A story as large as the creation of Route 128 and the birth and growth of the region's large, diverse, and ever-changing high-tech industry cannot begin to be fully encompassed in a book of this size. I have endeavored to provide a reasonably coherent and representative overview through the available photograph record. In many cases, availability has been the key. Many companies have ceased to exist. Others never had or never retained historical records. Thus, some companies are overrepresented here, others underrepresented, and many more are omitted entirely.

INTRODUCTION

Route 128 is more than a highway, although it earned plenty of accolades as just that. It is, as the blue signs boasted for many years, "America's Technology Region." Almost from its inception, when highway boosters thought they were simply relieving center city traffic congestion and providing avenues to recreation, the highway has attracted new businesses, particularly those spawned on government and university research soon to acquire the title high tech.

The story of Route 128, the highway, is a vital one. First proposed as far back as the beginning of the 20th century, Route 128's first incarnation was in the form of a route known variously as the Great Circumferential or the Boston Bypass, which knit together existing suburban roads in a north-to-south arc. Of course, since this road—which would today be considered a secondary highway—passed through many town and city centers, it was scarcely an improvement on driving through Boston itself. Thus it was that in the 1920s and 1930s, Massachusetts began to plan what would become the modern Route 128. Indeed, some construction actually commenced before World War II, and a short stretch in the Danvers-Lynnfield area was actually completed in the early 1940s. Work finally got into high gear in 1949, when Gov. Paul Dever signed into law an act providing for accelerated highway construction. His highway commissioner, William F. Callahan, then pushed forward construction along the highway's current alignment. By late 1951, the road was complete from Route 9 in Wellesley to Route 1 in Lynnfield and was popular from its opening days, although as the photographs included here show, it carried nothing like the present traffic volumes.

Within a few more years, 128 completed the arc around Boston, eventually connecting Gloucester and Braintree with 65 miles of tarmac. Plans to widen the road were also floated almost before the last sections were complete.

While Callahan and others saw to the completion of the road, businesses were also seeing its potential—notably real estate developers such as the David Nassif Company; Cabot, Cabot & Forbes; and Nordblom—and building some of the first modern, suburban industrial parks in the nation.

At the same time, a diverse corps of businesses, inventors, and entrepreneurs were also busy inventing high tech. Some, such as Raytheon and General Radio (later GenRad), had already been inventing and selling products for decades but had grown significantly under the impetus of wartime spending. They and others were ready when Cold War priorities and the demands of the space race put a premium on technical talent, flocking to Route 128 and the suburbs it helped make accessible. As for the inventors and entrepreneurs, many were about to become beneficiaries of one of the region's other innovations: the venture capital fund.

In the early 1950s, just as Route 128 was nearing completion, two important streams in the technology story were developing in parallel. First, the invention of the transistor produced a crop of semiconductor startups. Raytheon, already established as a maker of vacuum tubes, magnetrons, and radar systems, actually lays claim to the title of first commercial transistor producer, according to archivist and longtime executive Norman Krim. Raytheon helped revolutionize the hearing-aid business with this development, starting in 1947. By the late

1950s, however, Greater Boston was home to not only Raytheon but also to Clevite Transistor, Transitron, Sylvania, and later Unitrode and Sprague.

Similarly, largely on the strength of the Whirlwind computer project at the Massachusetts Institute of Technology (MIT), the region became a hotbed for new developments in computing, leading directly to the minicomputer companies that boosted employment in the region from the 1960s through the 1980s.

This season of promise was foreshortened by, among other things, the development of integrated circuits and by the growth of ever more formidable competitors in a nascent Silicon Valley and in Texas. Clevite, for example, was absorbed by Litton in the mid-1960s, and Transitron lingered on until the 1980s. And, of course, in the 1980s, the CPU-on-a-chip-powered PCs devastated the minicomputer makers. However, even in the boom years of the Massachusetts Miracle—the late 1970s through the late 1980s—seeds were being sown for new and exciting industries, software and biotechnology to name the most obvious candidates.

Those industries and others sustain the Commonwealth today. It is a process of renewal that began with Route 128 and that will probably include that venerable highway long into the future.

One

THE ROAD TO NOWHERE

While planners seem to have recognized the importance of Route 128, the idea of a circumferential beltway was new, and detractors labeled Route 128 the Road to Nowhere.

As noted in the introduction, some construction began in the 1930s and was accelerated under William F. Callahan between 1949 and 1951. The images in this section capture the later stages of construction, as the road came closer to completion in the 1950s. Quite a few also show now-familiar sections of the road during the long-running widening project, which extended through the mid-1960s.

Although the construction equipment of the time was less capable than that employed today, builders were also unhampered by environmental concerns, as some images illustrate.

The most striking images are probably those showing the road in use—many with hardly any cars in view, although by the time the road was widened, traffic was clearly heavier.

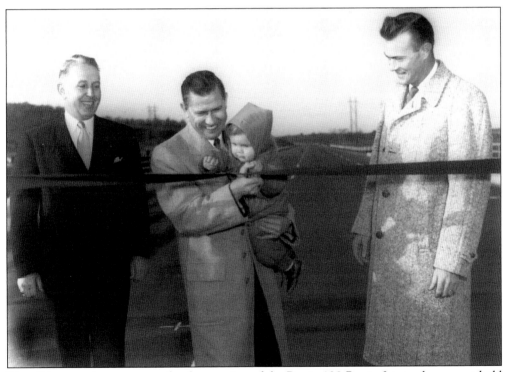

The ribbon-cutting ceremony for the opening of the Route 128-Route 3 interchange was held on November 11, 1954. Highway commissioner John A. Volpe is at the center, holding a little girl identified as the daughter of Bob Clays. (Courtesy Massachusetts Archive.)

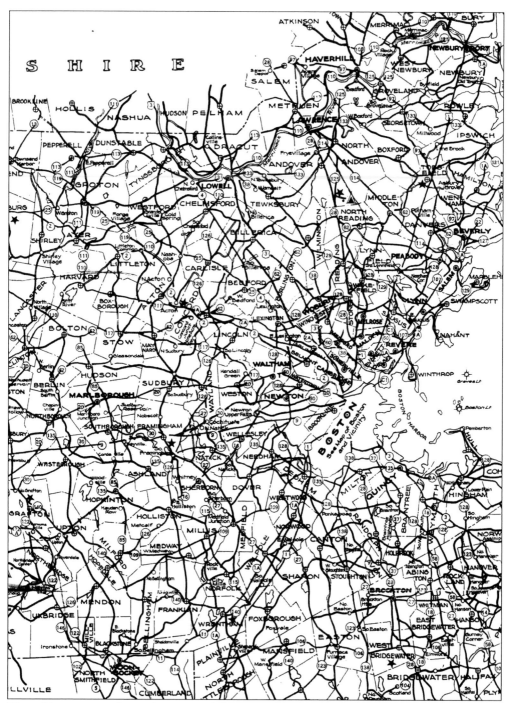

This old state map shows the route of the original Route 128, which meandered from Hull to Peabody and passed through the centers of Newton, Waltham, Lexington, Woburn, and Wakefield. It could scarcely have been a practical means of getting from the South Shore to the North Shore, even though it was a mere 55 miles in length. (Courtesy *Mass High Tech.*)

This 1955 view shows Route 128 near Route 58 on the South Shore. Early Route 128 images are hard to find. This is one of a handful retained by the Massachusetts Highway Department. (Courtesy Massachusetts Highway Department.)

This photograph looks east on Route 128, apparently on the road's southern reaches. Dr. Don Levitan of Suffolk University credits highway planners Benton MacKaye and Franklin C. Pillsbury as the prime influences on the shape and location of Route 128. (Courtesy Massachusetts Highway Department.)

A roller and a grader are at work on a section of a Route 128 interchange. In the background to the left, the beginnings of an overpass can be seen. (Courtesy Massachusetts Highway Department.)

Two off-highway dump trucks work in conjunction with an excavator, apparently carving an exit ramp. Note the continued use at this date of cables rather than hydraulics on the excavator. (Courtesy Massachusetts Highway Department.)

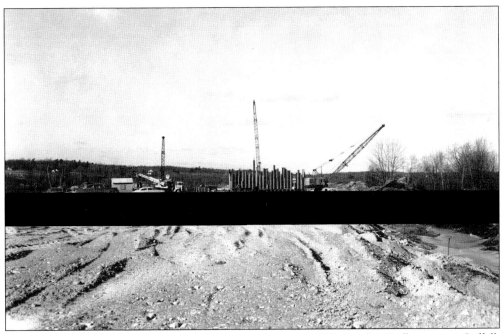

A Route 128 railroad overpass is under construction, possibly in the Dedham area. Suffolk University's Don Levitan says governors Robert F. Bradford and Paul Dever get much credit for the road's creation, but highway commissioner William F. Callahan, who also pushed through the Massachusetts Turnpike, "did more to complete the Circumferential than any of his predecessors." (Courtesy Massachusetts Highway Department.)

A section of Route 128 is shown incomplete in 1955. Construction of Route 128 to the south of Dedham was continued under the leadership of Gov. Christian A. Herter and public works commissioner John A. Volpe. (Courtesy Massachusetts Highway Department.)

13

An interchange is under construction in 1955. Although proposals for massive federal highway funding had been broached many times, notably toward the end of World War II, such funding did not materialize until the road was nearly complete. (Courtesy Massachusetts Highway Department.)

This view of the interchange shows progress on abutments. (Courtesy Massachusetts Highway Department.)

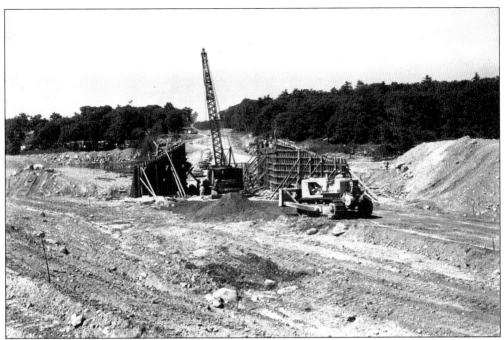

The narrowness of this bridge abutment makes it likely that this was designed to accommodate rail traffic. As Route 128 and the rest of the road network expanded, many of these railroads became unsustainable. Two rail bridges in the western suburbs met this fate. One in Lexington is now used for the Minuteman bike trail and the other, in Waltham, may become part of the Massachusetts Central bike trail. (Courtesy Massachusetts Highway Department.)

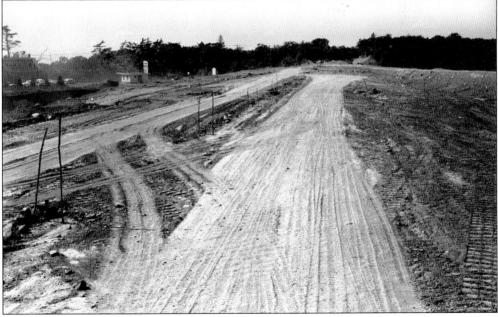

Another road section is ready for gravel and pavement. The original road section from Lynnfield to Weston cost only about $40 million between 1949 and 1953. (Courtesy Massachusetts Highway Department.)

A Buffalo-Springfield roller works in conjunction with a bulldozer, in the distance. Originally envisioned by Benton MacKaye as a means for connecting the parklands of the still nascent Bay Circuit—a creation of the Trustees of the Reservations—the road did, in fact, encourage recreational travel. Picnic benches could even be found along some stretches of the road. (Courtesy Massachusetts Highway Department.)

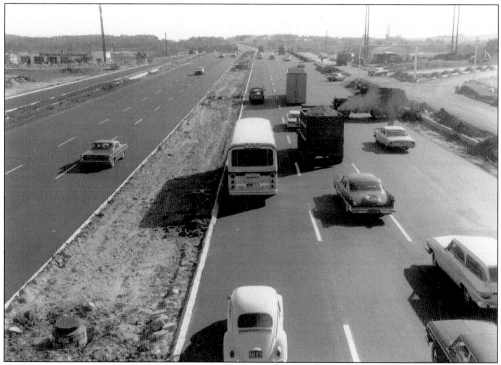

Route 128 soon became the way to get anywhere, or nowhere. In the 1970s, cruising Route 128 was memorialized by the local rock band Jonathan Richman and the Modern Lovers in their song "Road Runner."

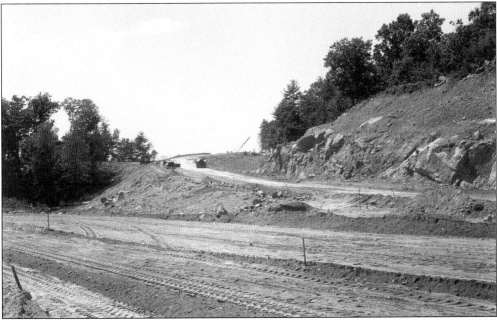

An exit ramp is in progress. The alignment and scale of many of the road's interchanges was often less ideal than that demanded for later, federally funded roads. (Courtesy Massachusetts Highway Department.)

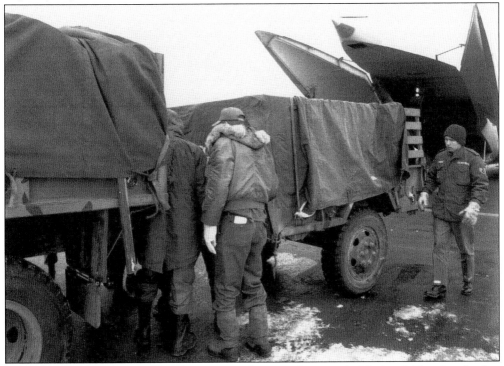

The Blizzard of 1978 shut down business in the state for a week. National Guard and other military units, some shown here arriving by air, were key to recovery. Guard units helped rescue scores of motorists trapped on Route 128.

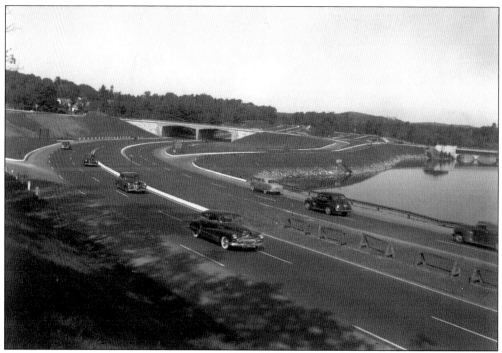

This is scene is along Route 128 in Waltham near the original, much smaller Route 30 interchange. With the coming of the Massachusetts Turnpike Extension, an additional interchange was created atop this site. (Courtesy *Mass High Tech*.)

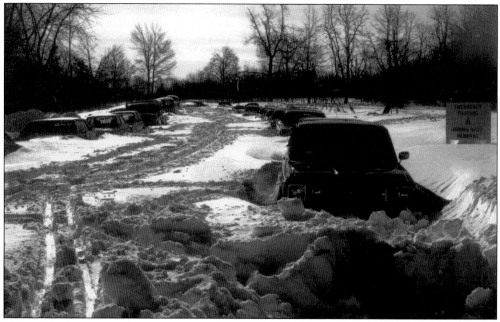

The road's ultimate traffic jam occurred when motorists were unable to get off exit ramps during the memorable Blizzard of 1978, causing a backup that halted plowing and led to hundreds of motorists being stranded on the road, some for days. This image shows the results of the blizzard at nearby Hanscom Air Base. (Courtesy U.S. Air Force.)

In this 1962 image, excavators chew away at a hillside on the Burlington-Lexington line as part of the Route 128 widening project. (Courtesy Massachusetts Highway Department.)

Work progresses on a median strip in the Burlington-Lexington area. For the most part, the road avoided heavily populated areas and, in fact, usually skirted the edges of towns and cities. (Courtesy Massachusetts Highway Department.)

As part of the Route 128 widening project, two interchanges ultimately got this updated interstate-style merge lane. Shown here is the interchange with Route 3, which, at the time the photograph was taken, was still slated for expansion directly into Boston. The other interchange to get this style of ramp was at Interstate 95 in Canton. The extension of Interstate 95 into Boston never happened and, instead, Route 128 assumed the Interstate 95 designation over part of its length. (Courtesy Massachusetts Highway Department.)

More widening work is shown in the Burlington-Lexington area. Note the cavalier invasion of the wetland area. Today, similar work would be heavily regulated, supervised, and mitigated. (Courtesy Massachusetts Highway Department.)

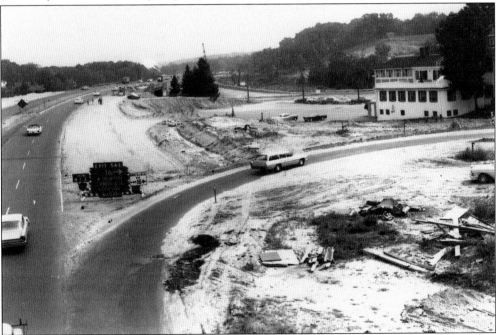

Widening work comes to the Newton-Wellesley area. Here, the Route 16 exit and the Pillar House restaurant can be seen. Commuters ever since have probably wished the widening had continued a few more miles to eliminate the lane drop at Route 9. (Courtesy Massachusetts Highway Department.)

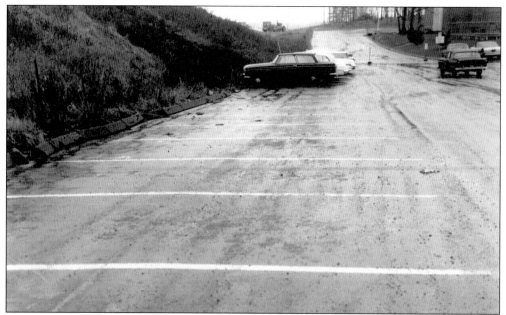

This section of the Raytheon Spencer Lab parking lot, in Burlington, is in the shadow of the widening project prior to the installation of a sewer line and retaining wall. (Courtesy Massachusetts Highway Department.)

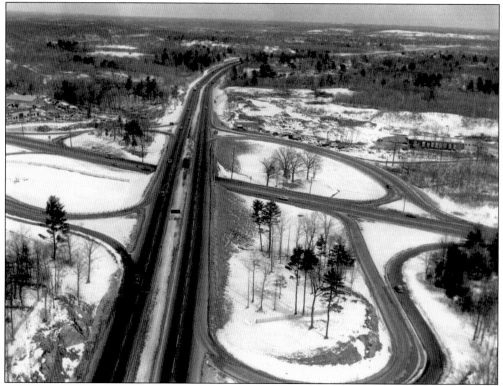

This aerial view of the Route 128 and Route 3A interchange in Burlington, looking north, was taken prior to the widening project. (Courtesy Massachusetts Highway Department.)

This is the Route 114 overpass in Danvers in 1962. Daytime traffic volumes this low are a distant memory. The northern end of Route 128 was where much of the originally envisioned recreation occurred at locations such as H.P. Hood's Cherry Hill model dairy and in Wakefield at Pleasure Island, a Disney-like theme park. (Courtesy Massachusetts Highway Department.)

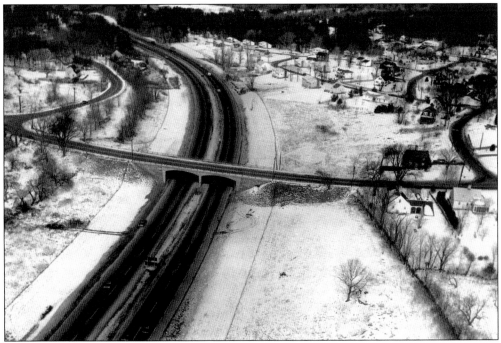

This is Massachusetts Avenue and Route 128 in Lexington. Note the car off the road to the left and its apparent traverse across both the northbound and southbound portions of the road. Surely there is a story behind this. (Courtesy Massachusetts Highway Department.)

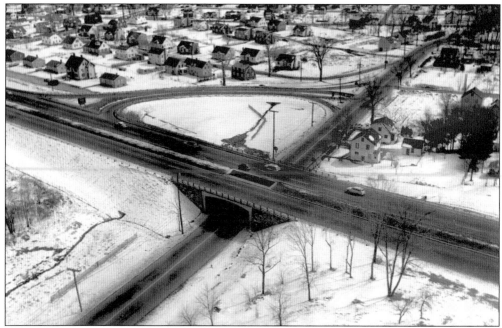

Route 128 at Winn Street is seen in the early 1960s. Those trying to find the locations of the original exits will find the process confusing, since all were renumbered in the 1960s. (Courtesy Massachusetts Highway Department.)

This is a much later aerial view of Route 128—the Centennial Drive area of Peabody in the 1980s. In the distance can be seen the progress of the current Interstate 95–Route 128 interchange, which replaced a confusing and outmoded linkage with Route 1 in the late 1980s. (Courtesy Massachusetts Highway Department.)

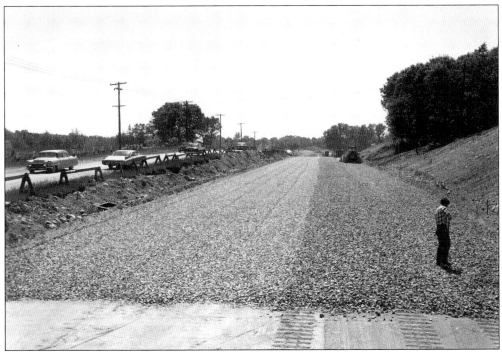

This undated image of early-1960s construction on 128 is probably the widening project. Hand labor was still a fairly visible part of construction projects at this time. (Courtesy Massachusetts Highway Department.)

A rest area on the southbound side of Route 128 in the late 1960s shows the Great Blue Hill in the background. (Courtesy Massachusetts Highway Department.)

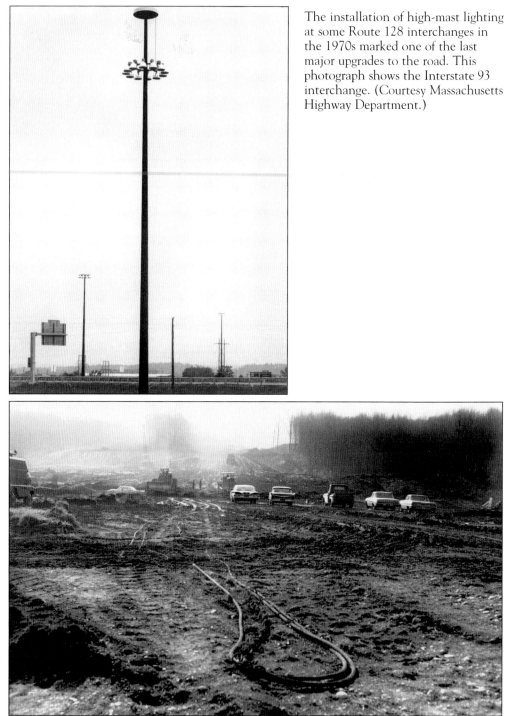

The installation of high-mast lighting at some Route 128 interchanges in the 1970s marked one of the last major upgrades to the road. This photograph shows the Interstate 93 interchange. (Courtesy Massachusetts Highway Department.)

Even as Route 128 was being completed, federal funding became available. Political maneuvering by John A. Volpe and others allowed application of federal funding to the even larger circumferential highway, Interstate 495. This shot was taken in Southborough in the early 1960s. (Courtesy Massachusetts Highway Department.)

This photograph shows the progress of Interstate 495 through the Chelmsford area c. 1962. (Courtesy Massachusetts Highway Department.)

The junction of Route 3 and Interstate 495 is seen at the time the latter road opened. Route 128 and Interstate 495 soon became complementary centers of development. (Courtesy Massachusetts Highway Department.)

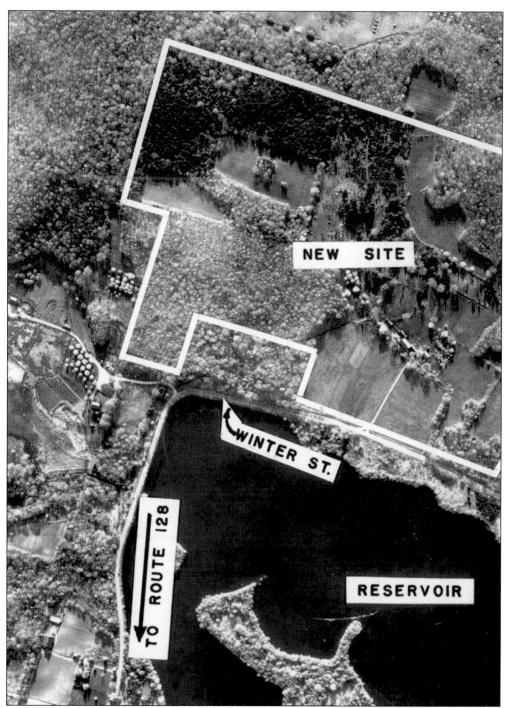

An undated aerial photograph of the Waltham-Lincoln line near Route 128 shows development plans. Note the amount of open land, which included a piggery. The area labeled "new site" eventually became the Bay Colony Corporate Center in the 1980s. (Courtesy Boston Public Library.)

Two

PIONEERS

Even before Route 128, there was a growing high-technology sector in eastern Massachusetts. Raytheon was the most obvious example. Started just after World War I, it saw business grow enormously during World War II and, despite a period of retrenchment after the war, never looked back. Raytheon's success was partly a result of the radiation laboratory, set up under government sponsorship at MIT during the war. Many companies, including M/A-COM, trace their roots to the lab. After the war, the government-funded Whirlwind computer project made the region a hotbed for computer development. Other companies were also launched in the postwar environment, building on new electronic, computer, and semiconductor technologies. By the late 1950s, Route 128 was no longer the Road to Nowhere but, instead, the Golden Crescent or Golden Semicircle. Still, high tech was not as large as many of the traditional industries in the region.

The pioneering years of high tech extended from the end of World War II through, roughly, the end of the Vietnam War, when high tech emerged as a dominant industry.

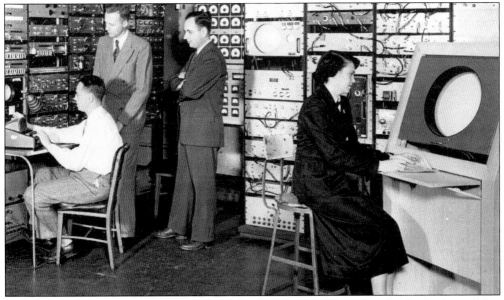

Whirlwind—a pioneer digital computer developed at MIT under the leadership of Jay Forrester—ended up helping to spawn a number of major enterprises, including the MITRE Corporation and Digital Equipment Corporation, and was a blueprint for much of what became the computer industry. Here, Forrester (standing, left) and Robert Everett (standing, right) observe the operation of the Whirlwind computer. Everett later became the technical director and third president of MITRE. Seated at the test console and the display scope, respectively, are Stephen H. Dodd and Ramona Ferenz. (Courtesy MITRE Corporation.)

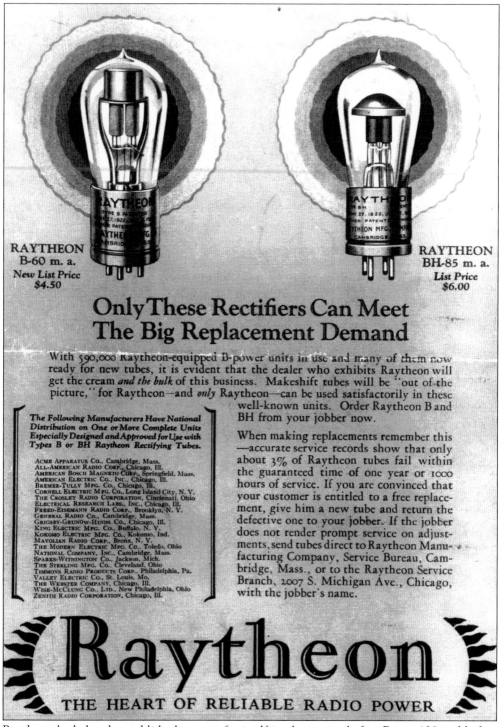

Raytheon had already established a name for itself in electronics before Route 128 and before World War II. This 1930s advertisement pitched a major Raytheon breakthrough—a rectifier tube that made AC-powered radios practical. (Courtesy Raytheon.)

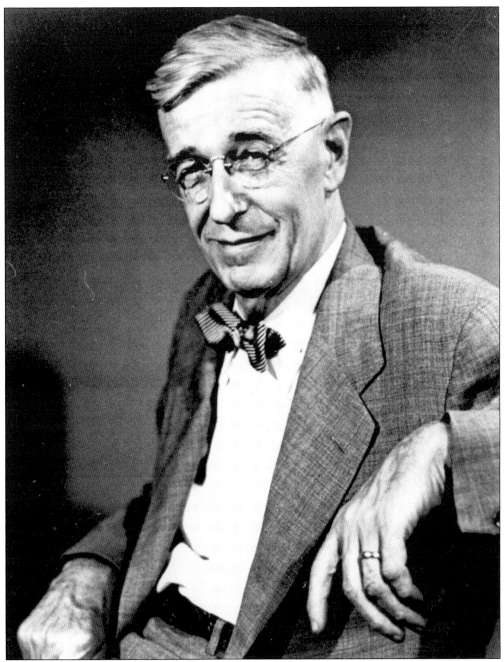

MIT's Vannevar Bush, science advisor to President Roosevelt during World War II, was a cofounder of Raytheon in the 1920s and a pioneer of computing (albeit using mechanical rather than electronic technologies). (Courtesy Raytheon.)

Percy Spencer was a prodigious talent who helped guide Raytheon's research and engineering for many years. His manufacturing breakthroughs allowed Raytheon to take the lead in mass-producing the crucial magnetron tube used in radars. By the end of World War II, Raytheon was supplying not only key components but also many advanced radar systems. (Courtesy Raytheon.)

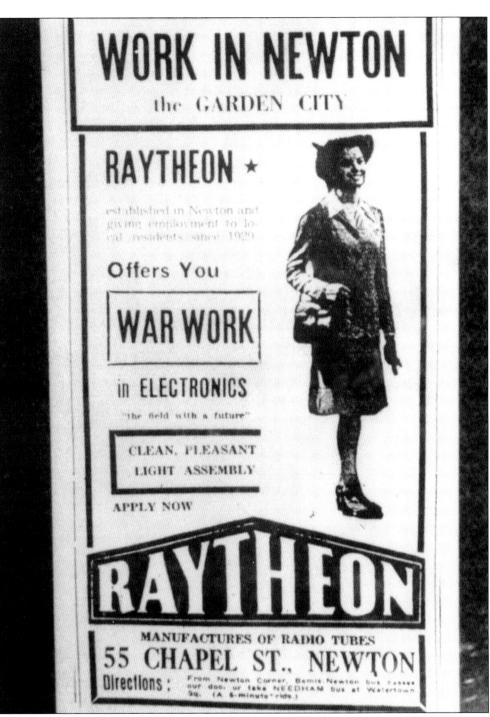

Raytheon's manufacturing breakthroughs made it necessary for the company to hire thousands of new workers during the war. Many were women. The company even wrote glowing descriptions about the jobs available—in one instance, citing the case of a Watertown hairdresser who had happily traded her career in the beauty business for opportunity in the world of electronics. (Courtesy Raytheon.)

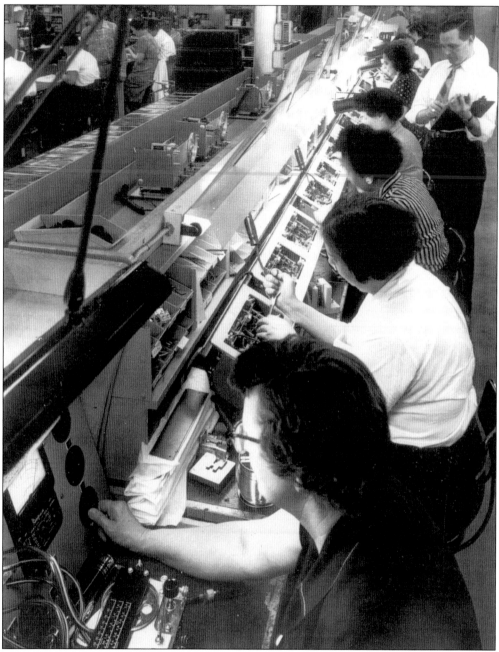

According to Raytheon's archivist, this photograph shows women assembling radar sets during World War II. Although women were recruited and trained in large numbers, supervisory roles were often retained for males. The woman in the foreground appears to be performing tests on the equipment. (Courtesy Raytheon.)

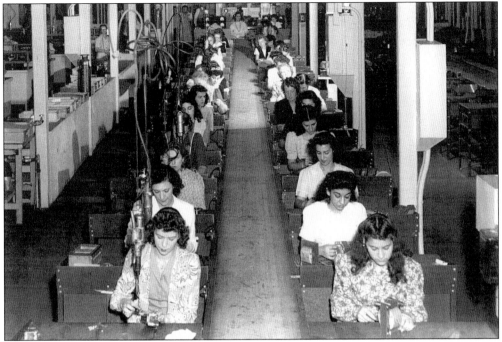

A wartime assembly line produces transformers, chokes, regulators, and rectifiers. Women were often particularly valued for electronic work because of their dexterity. At the time, most Raytheon facilities were concentrated in Waltham and Watertown. Some remain there today. In 1961, the company opened its new headquarters at the intersection of Route 128 and Route 2, joining other 128-area facilities, such as the Spencer Lab in Burlington and facilities near Hanscom Field in Bedford. (Courtesy Raytheon.)

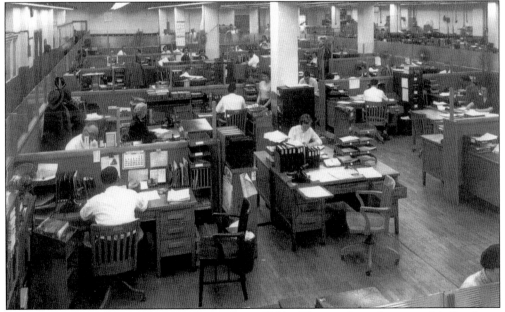

This is a typical office scene from the 1940s or 1950s. The number of men in this Raytheon photograph makes it likely that this is from after World War II. (Courtesy Raytheon.)

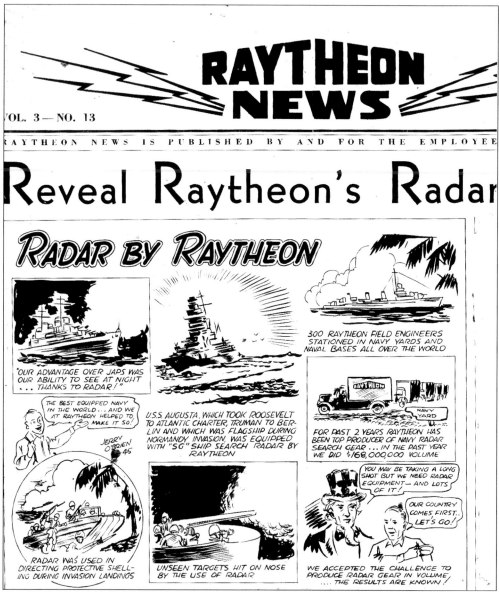

This 1945 Raytheon employee newsletter told the story of Raytheon's radar successes in the form of a cartoon. (Courtesy Raytheon.)

RAYTHEON SG RADAR SYSTEM. This represents the first successful widely-used general-purpose shipborne surface-search radar, with successive major improvements. It is used on battleships, cruisers, aircraft carriers, destroyers, troop transports, communication ships, and other large ships of the Navy and the Coast Guard.

The system is a continuous-duty, heavily-built equipment designed to withstand the rigors of combat duty.

Uses of the equipment are for navigation, station-keeping in escort-of-convoy or other task force operations, maneuvering, target tracking, periscope detection, and as an auxiliary fire-control radar. These functions during darkness or other periods of reduced visibility during darkened-ship condition make the equipment of utmost value.

MAIN RAYTHEON SG ship search radar. Operator is obtaining accurate range and bearing of target.

RAYTHEON PRECISION RADAR REPEATER. Enables operator to obtain very accurate information. On the right is a "sweep," which is a rectangular plot, with range and bearing as the co-ordinates. In this "sweep" the target is enlarged.

The second page of the newsletter provided more details on Raytheon's technological triumph. Winding down from war work, however, was painful for Raytheon and its host communities. Employment had ballooned to about 18,000 from 1,500 before the war, and sales increased to $180 million a year from $3 million a year before the war. (Courtesy Raytheon.)

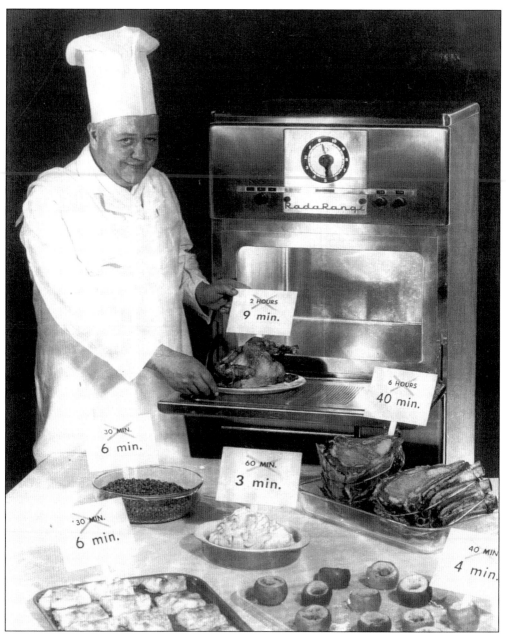

Based on its microwave radar prowess, Raytheon invented the microwave oven. Percy Spencer filed the first U.S. patent in October 1945. Raytheon swiftly capitalized on the potential of this technology in the commercial market. Here, a 1948 company publicity shot shows the swift cooking capability of the new RadarRange. (Courtesy Raytheon.)

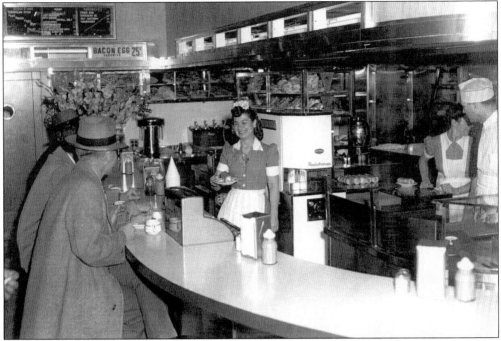

The smiling waitress in this diner is flanked by a RadarRange. Note the sign hawking a bacon-and-egg sandwich for just 25¢. (Courtesy Raytheon.)

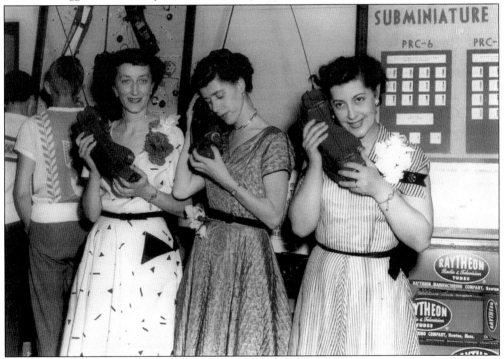

Raytheon was a large force in vacuum tubes, including miniature tubes used in portable radios and hearing aids. In this postwar photograph, three women, probably employees, test the heft of portable military radios. (Courtesy Raytheon.)

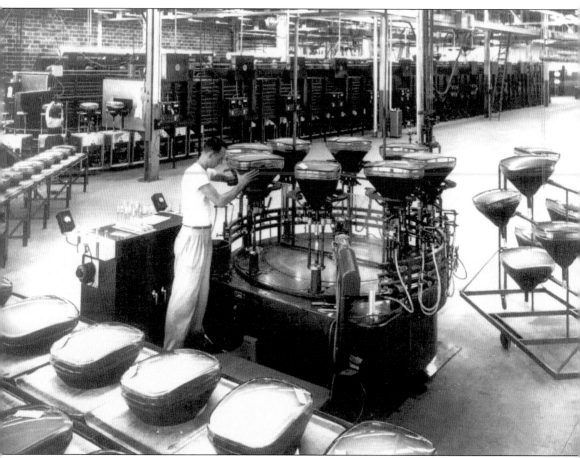

This view shows television picture tube exhaust operations at Raytheon's Quincy plant. Raytheon made not only television tubes but also television sets and radios during the 1950s. (Courtesy Raytheon.)

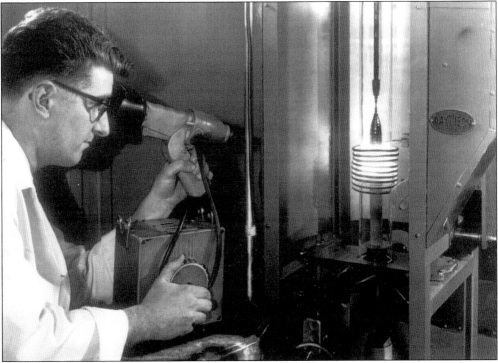

Although deeply committed to tube technology, Raytheon was quick to recognize the potential of transistors and, according to the company archivist, was the first to market a commercial version for use in hearing aids. Here, a technician measures the temperature of a germanium crystal for transistor production in 1956. (Courtesy Raytheon.)

According to Raytheon's archive, this photograph shows an aging rack for transistors in the mid-1950s. This was a process used to ensure reliability. (Courtesy Raytheon.)

Raytheon was not the only company to jump into semiconductors. In this building, the former headquarters of the Waltham Watch Company, Clevite Transistor got its start. The author's father, an engineer at the company, recalled that the failure rates were extremely high—barrels were filled with defective components every day. Such problems were found industry-wide, as the technology was being invented day by day. Clevite even recruited geologists to help them master the difficulties of processing germanium. (Courtesy National Archives.)

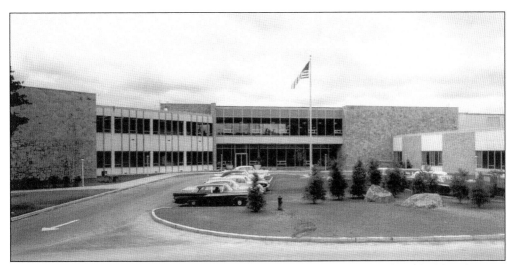

Notwithstanding its technical challenges, Clevite was successful enough to build a gleaming new facility near the Trapelo Road interchange with Route 128. The facility was named as one of the top 10 new manufacturing plants completed in the United States during 1960. If the flag is politically correct, it would have just been updated with two new stars to honor the admission to the union of Hawaii and Alaska in 1959. When Honeywell later took over the building, a relatively shallow basement, which had been designed to handle piping for semiconductor processing, was pressed into service as office space. (Courtesy Boston Public Library.)

This image shows an organism of great historical significance, reportedly first identified and named by Lt. Grace Murray Hopper while she was on navy active duty in 1945. It is a moth found trapped between points at Relay No. 70, Panel F, of the Mark II Aiken Relay Calculator—a pioneer computer—while it was being tested at Harvard University on September 9, 1945. The operators affixed the moth to the computer log, with the entry "first actual case of bug being found." They put out the word that they had "debugged" the machine, thus introducing the expression "debugging a computer program." Hopper later went on to become the prime force in creation of the COBOL computing language. (Courtesy U.S. Navy.)

Although many technology companies, particularly startups, stayed with drab and industrial-looking facilities, most high-tech companies made a point of providing a clean, smartly appointed facility. This 1961 view of the foyer and cafeteria at Clevite's new semiconductor-production and research-and-development facility in Waltham shows an example of this trend. When Clevite, which had its roots in the unrelated bushing business, sold its semiconductor operations to Litton in the mid-1960s, Honeywell's Electronic Data Processing division moved in. The author's father worked in the building, successively, for Clevite and Honeywell. Makers of large computers, Honeywell's mainframe business and its smaller computer unit, which had been headquartered in Billerica, was swallowed by the France-based Groupe Bull in the 1980s. (Courtesy Boston Public Library.)

Georges Doriot, beloved Harvard Business School professor, traded academia for the role of general in the U.S. Army Quartermaster Corps during World War II. Doriot was responsible for many innovations in the quality of goods used by the military and for the organization of supply systems, and his work led to creation of the U.S. Army Natick Labs. Here, Doriot is shown with Col. Paul Siple, who had won fame as a youth as the "Boy Scout with Byrd," accompanying Boston's famous navy admiral on his antarctic expedition. Doriot later won more accolades for helping launch the modern venture capital industry in 1946. (Courtesy National Archives.)

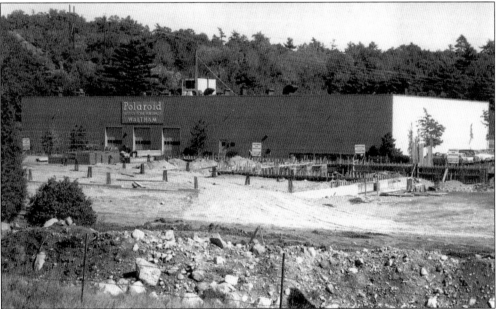

In 1956, when this photograph of a new Polaroid facility in Waltham was taken, the company's instant photography business was less than a decade old. Although still committed to a large presence in Cambridge, the company increasingly looked to the suburbs and outlying areas for its new facilities. In Waltham, it gained close proximity to two Route 128 interchanges and an active commuter rail line. The sign says, "First of Four Buildings." (Courtesy Boston Public Library.)

Venture capitalist Gen. Georges Doriot was the éminence grise behind many of the region's high-tech companies. He was most famous for having funded Digital Equipment Corporation with an initial $70,000. He also mentored the company's management for many years. He was well known for his paternal advice, such as telling Digital founder Ken Olsen to keep mowing his own lawn so he would not get too taken with his own success. In addition to his leadership of American Research and Development (ARD), Doriot also had a long and distinguished career at the Harvard Business School, where he taught a course simply titled "Manufacturing" from the 1920s through the 1970s.

Denis Robinson was president of High Voltage Engineering, a company that was launched right after World War II with funding from American Research and Development and moved to quarters on Route 128 by 1954. When asked about the role of Doriot in his success, Robinson told the author, "He meant a great deal to me. He stayed on our board for 20 years, for which I was incredible grateful. . . . He never failed to be aggravating and stimulating. He intended that. He did not care to be loved. He wanted to be useful." (Courtesy *Mass High Tech.*)

This photograph was taken in 1964, a time when technology publishing was a small business. It shows Patrick J. McGovern, the founder and chairman of International Data Group (IDG), publishers of magazines such as *Computerworld* and also a major player in technology analytics. Behind him is the "grey house" in Newton where IDG originated. IDG is now a $3.01 billion company, operating in 85 countries with more than 12,000 employees. (Courtesy IDG.)

The U.S. Air Force Cambridge Research Laboratory was a major site for technological innovation during the Cold War. The laboratory moved gradually from Cambridge to Hanscom Air Base near Route 128 from the mid-1950s to the early 1960s. This photograph seems to date from the 1960s or 1970s. The man is identified as F. Giusti. (Courtesy U.S. Air Force.)

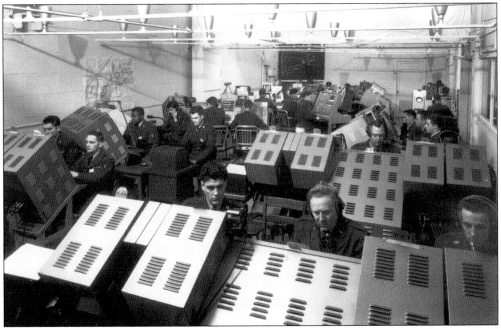

Defense work continued to be a mainstay of the region's high-tech companies. The Cape Cod System was an early computerized air defense radar system, which became the prototype for the much larger SAGE (Semi-Automatic Ground Environment). It was based around the computing capability of the Whirlwind computer housed at MIT. (Courtesy *Mass High Tech.*)

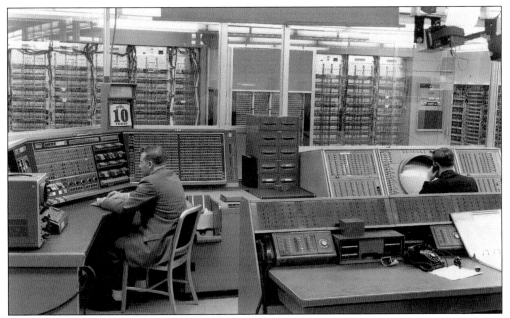

Pictured are the control consoles of the XD-1 computer for SAGE experimentation in Building F at MIT's Lincoln Laboratory. With the exception of a few models produced in relatively large numbers by IBM and a few other companies, computers of this era were almost always works in progress, subject to ongoing tinkering and endless repair. (Courtesy MITRE Corporation.)

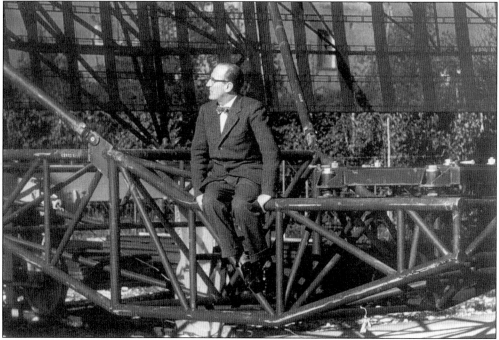

Dr. Carlo Calosi strikes a pose on a Raytheon radar dish. Calosi had been spirited out of Italy by the OSS (Office of Strategic Services) after the Italian surrender in 1943. He had designed the electronics for a highly successful Italian magnetic torpedo and was considered a vitally important technologist. Later, at Raytheon, he rose to become a vice president. (Courtesy Raytheon.)

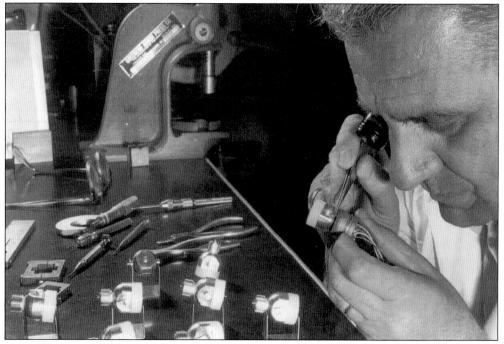

A Raytheon technician works on accelerometers for missiles in this 1956 photograph. (Courtesy Raytheon.)

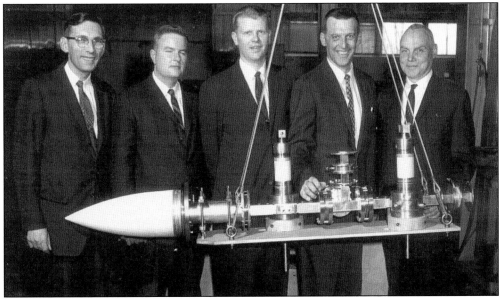

William C. Brown (right) and a team of Raytheon engineers show off a high-power microwave amplifier electron tube in this photograph from the 1950s or 1960s. (Courtesy Raytheon.)

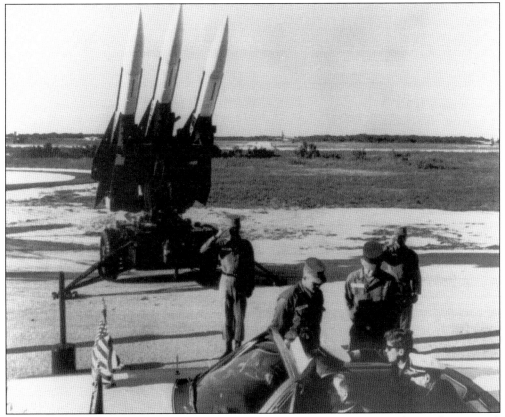

Bay State–born Pres. John F. Kennedy inspects a battery of Bay State–made Raytheon Hawk missiles in south Florida during the Cuban Missile Crisis of 1962. (Courtesy Raytheon.)

Startup Teradyne's first home was on the third floor of 87 Summer Street in Boston. Because cofounders Nick DeWolfe and Alex d'Arbeloff both lived in Boston and wanted to walk to work, Teradyne, a fast-growing upstart in the testing business, became one of the few tech firms to buck the trend of moving to Route 128 or beyond. (Courtesy Teradyne.)

Teradyne cofounders Alex d'Arbeloff and Nick DeWolfe are pictured on the production floor at Summer Street in the early 1960s. (Courtesy Teradyne.)

Teradyne later moved to 183 Essex Street and stayed there from 1965 to 1984. (Courtesy Teradyne.)

Teradyne cofounder Alex d'Arbeloff solders at Summer Street. Although executives like d'Arbeloff had to roll up their sleeves sometimes, Teradyne quickly became profitable and a major force in the testing field. (Courtesy Teradyne.)

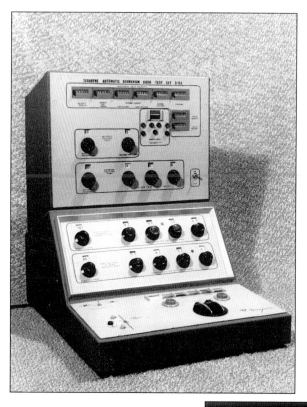

Teradyne's first product was the D133 Diode Tester. Test limits were programmed by front-panel rotary switches, diodes were placed on a magnetic test clip, the operator pushed a right- or left-hand start button, and test results were indicated by green (pass) or red (fail) lights. (Courtesy Teradyne.)

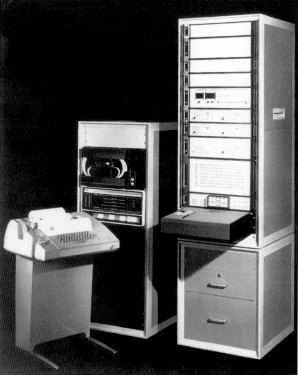

Teradyne's J259 was the industry's first computer-operated IC test system. Nick DeWolfe, Teradyne cofounder, long insisted that the company's model numbers should be primes. (Courtesy Teradyne.)

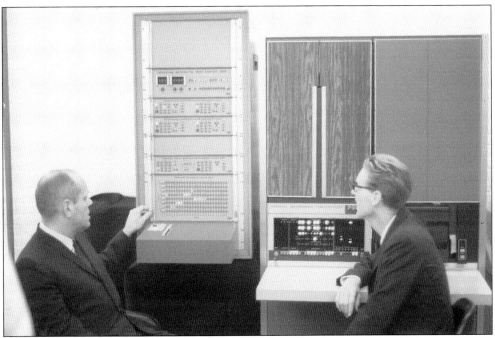

Teradyne's Nick DeWolf (right) and Digital Equipment Corporation's (DEC) Ken Olsen are pictured at the J259, which incorporated a Digital minicomputer. On the strength of the J259, Teradyne quickly became one of Digital's largest customers. (Courtesy Teradyne.)

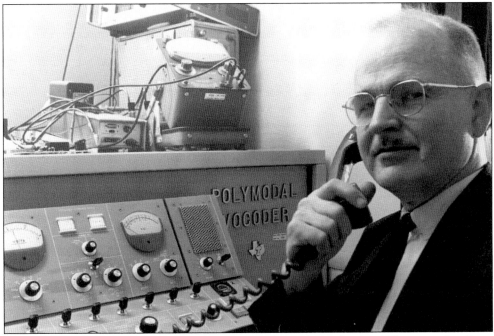

This intriguing photograph of a vocorder comes from the archives of Hanscom Air Base. Hanscom's work eventually focused in on electronic systems and often involved close work with other local organizations, such as MITRE and MIT's Lincoln Laboratory. (Courtesy U.S. Air Force.)

A multistation Teradyne transistor tester of the 1970s is shown here. The distinctive kiosk rack was designed by Walter Kern to simplify access. The system's computer, in the second kiosk from the right, is a Teradyne-built and designed model dubbed the M365. (Courtesy Teradyne.)

High tech could be lighthearted. This photograph shows the Teradyne Follies' Chorus Line, the Terabelles—a tradition started with the 1972 Christmas party. (Courtesy Teradyne.)

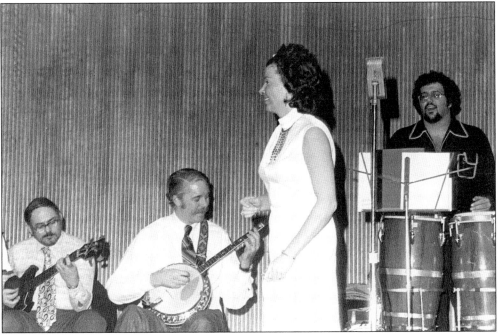

Arlene Harrington is the Elevator Girl in the Teradyne Follies—a company skit—accompanied by Joe Laquidara on guitar and Ed Sutherland on the banjo. There were also sometimes comic parodies of company president Alex d'Arbeloff recast as a character called Alex Telemoff. (Courtesy Teradyne.)

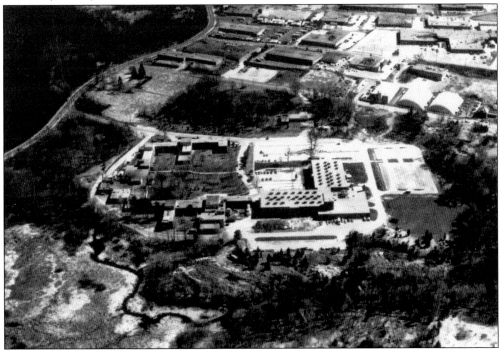

This aerial view shows GTE's corporate research campus near Totten Pond Road on the edge of Waltham. (Courtesy Waltham Public Library.)

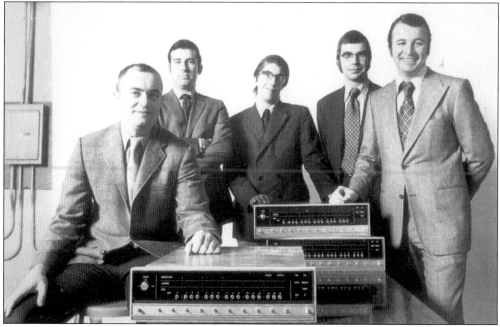

Digital Equipment Corporation started the minicomputer revolution, and others followed its lead. This photograph shows the key personnel for Data General, some of whom had come from Digital, in Hudson with the first Nova minicomputer. The company was soon to be Digital's fiercest rival. They are, from left to right, Edson D. deCastro, president; Harvey P. Newquist, manufacturing vice president; Henry Burkhardt III, programming-software vice president; Richard Sogge, engineering vice president; and Herbert J. Richman, sales vice president. (Courtesy Ed McManus.)

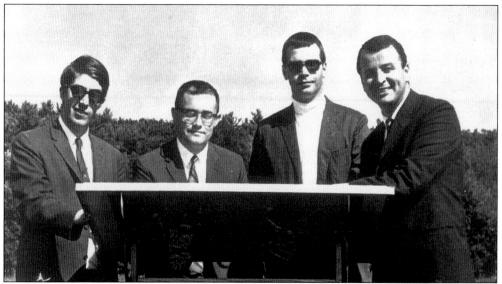

Data General founders plan the first Southborough plant. They are, from left to right, Henry Burkhardt III, Edson deCastro, Richard Sogge, and Herbert J. Richman. The engineering efforts of Data General were later memorialized by Tracy Kidder in the bestselling book *Soul of a New Machine*, which won the National Book Award in 1982. (Courtesy Ed McManus.)

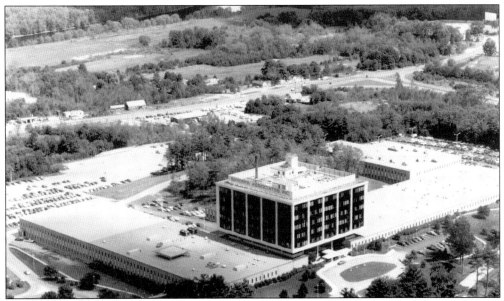

Sanders Associates, founded by former Raytheon executive Royden C. Sanders in the 1950s, established this modern headquarters just across the New Hampshire border in Nashua. The company continued to pursue primarily defense-related business. (Courtesy *Mass High Tech*.)

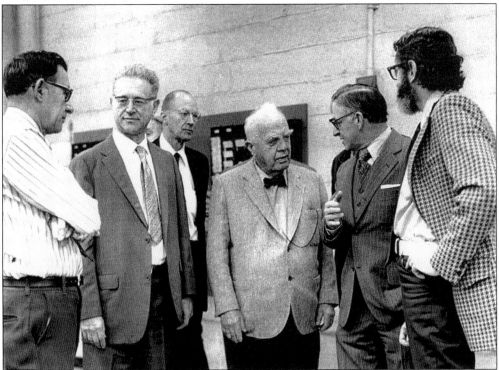

This photograph captures Laurence K. Marshall's return visit to Raytheon in the early 1970s, his first since retiring from the company *c*. 1950. Marshall was one of the company's founders. Pictured, from left to right, are Ralph Montanari, Norman Krim, Al White, Laurence K. Marshall, Dan Hamant, and Bill Philbin. (Courtesy Raytheon.)

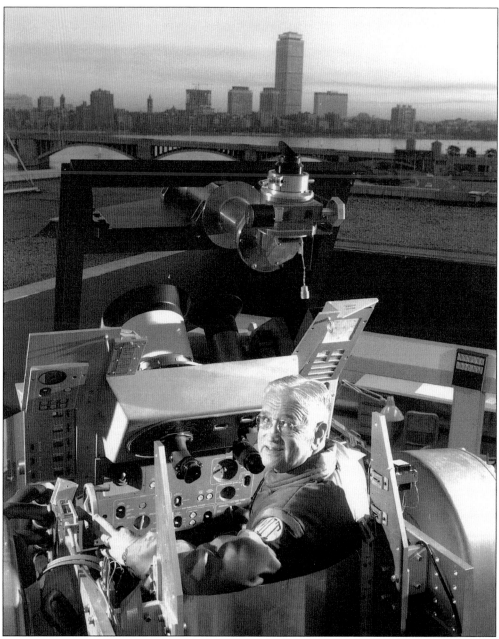

Linked by MIT to Cambridge, the MIT Instrumentation Laboratory, later the Charles Stark Draper Laboratory, was led by the inventive Charles Stark Draper. The lab played a key role in many defense and space program efforts. Here, "Doc" Draper is shown on the roof of the lab in 1968, testing the Apollo program's celestial sightings. (Courtesy the Charles Stark Draper Laboratory Inc.)

This man, identified as Ed Duran, is shown at the Air Force Cambridge Research Laboratory (AFCRL), located at Hanscom Air Base. The laboratory and its successor, the Electronic Systems Division, were magnets for funding and helped bring many military contracts to the region. (Courtesy U.S. Air Force.)

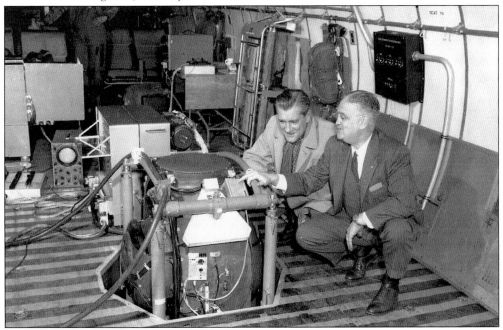

CBS TV's Eric Sevareid and Draper are shown in 1957, shortly before the flight of SPIRE Jr., a refinement of the original SPIRE system of inertial navigation. (Courtesy the Charles Stark Draper Laboratory Inc.)

INSTRUMENTATION LABORATORY
MASSACHUSETTS INSTITUTE OF TECHNOLOGY
CAMBRIDGE MASS.

PREPARED BY J.H. Laning Jr.
DATE: 3/53

(Tape T-2134-m8 plus)
(correction tape P-2134-10)

FILE 2100
J.H. Laning Jr.

a1 (Read-in)

START	→0	si 128	
NORMAL	16n →1	ao 36n	
RE-ENTRY	→2	rd 2n	
	(1a4) 3	ad (a3/103)	(l.c. or u.c.)
	4	td 8n	
	5	td 40 a4	
	6	td 14n	
	7	td 22n	
	(4n)8	ca (-)] Is symbol
	9	su 4a3] a number?
	10	cp 12n	
	11	sp (33a4/58a4)	
10n →	12	ca (33a3/31a3)	(31a3 is the
	13	td 11n	normal mode)
	(6n) 14	ca (-)	
	15	su 0	(Is symbol a period?)
	16	cp 1n	
	17	su 54a3] l.c. no. or
	18	cp 45a4] exponent?
	19	ca 43a3] set to interpret
	20	td 60 a4] digit as an
	21	cs 62a4] exponent
48a4	(n)22	ad (-)	
	23	cp 39n	→ if digit is zero
	24	st 51a3] Form (24,6) version
	25	ts 43n] of digit as an
	26	ca 11a4] integer in (43n,44n)
	27	su 51a3	
	28	sl 9	
	29	ts 44n]
	30	ca 25n	
	31	td 34n	

Another breakthrough by the Draper team was Dr. Hal Laning's notations for the world's first algebraic compiler. (Courtesy the Charles Stark Draper Laboratory Inc.)

Dr. Hal Laning was a crucial leader in the lab's computing projects for many years. (Courtesy the Charles Stark Draper Laboratory Inc.)

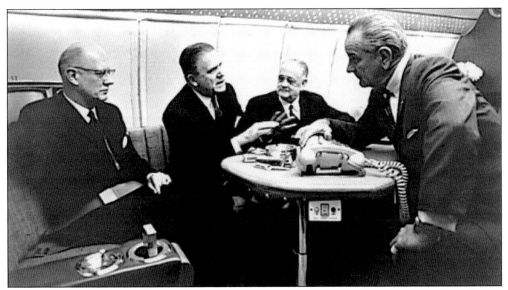

NASA administrator James Webb and Charles Stark Draper confer with Pres. Lyndon Johnson during the Apollo space program. (Courtesy the Charles Stark Draper Laboratory Inc.)

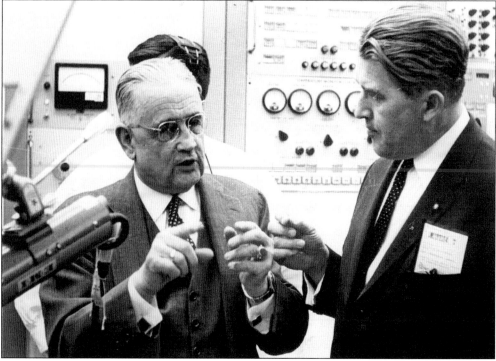

Charles Stark Draper is in conference with NASA's Werner von Braun. (Courtesy *Mass High Tech*.)

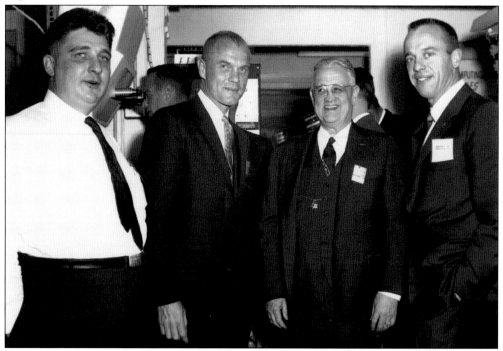

Draper is flanked by astronauts John Glenn (left) and Alan Shepard. At the far left is Milt Trageser, part of the Draper team. (Courtesy *Mass High Tech*.)

Margaret Hamilton, a programmer for Draper, is shown here in the late 1960s. She was responsible for producing software for the ultra-advanced Apollo guidance computer (seen below). Years later, Hamilton told the author that undiscovered bugs could have caused early moon missions to fail, leading her to pursue research in software reliability. (Courtesy *Mass High Tech*.)

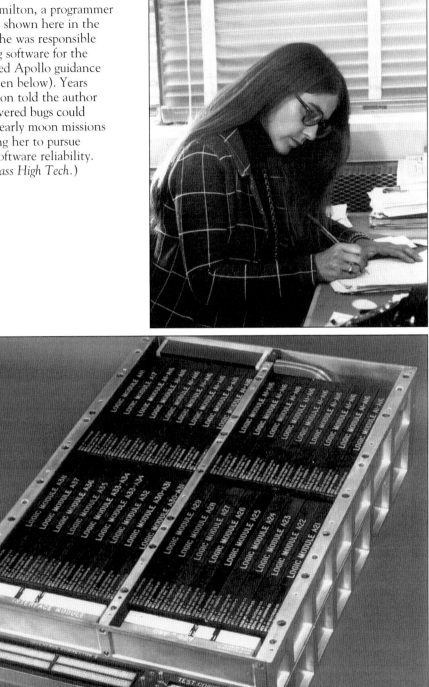

The Apollo guidance computer, manufactured by Raytheon, was a miracle of miniaturization in an era when even minicomputers were as large as a refrigerator. It had a total of 4,100 integrated circuits and was the first computer to be constructed entirely using the new technology. (Courtesy Raytheon.)

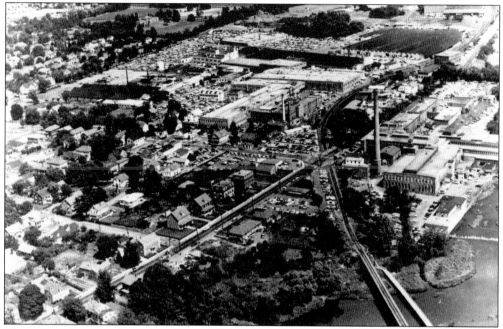

These two photographs, taken from different directions, show the expansion of Raytheon in Waltham from the 1950s (above) to the 1970s (below). Waltham reaped a benefit in employment for locals but suffered traffic woes with such a large facility nestled among residential neighborhoods. By the 1960s, many Raytheon facilities had been moved to the 128 and 495 areas. Defense and aerospace work was a critical component in the local high-tech industry through the 1950s and 1960s. The end of the Vietnam War, the completion of the Apollo program, and détente with the Soviet Union produced a deep recession along Route 128 in the early- to mid-1970s. (Courtesy Waltham Public Library.)

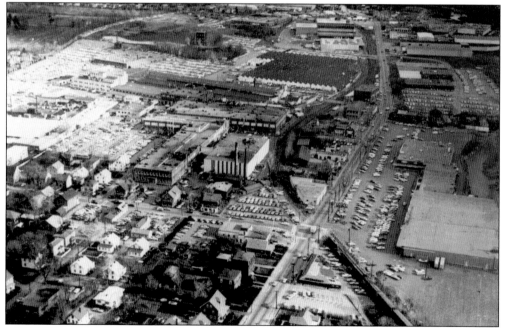

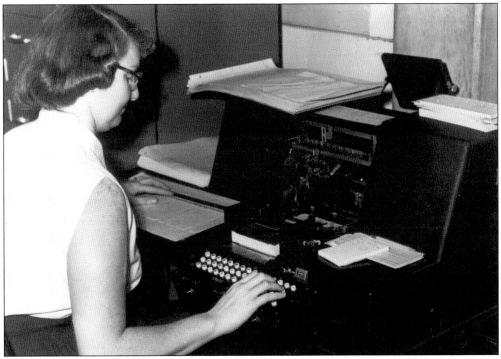

The punch card was the cornerstone of computing even into the 1970s and early 1980s. Here, a key punch operator enters data at the Air Force Cambridge Research Laboratory at Hanscom. (Courtesy U.S. Air Force.)

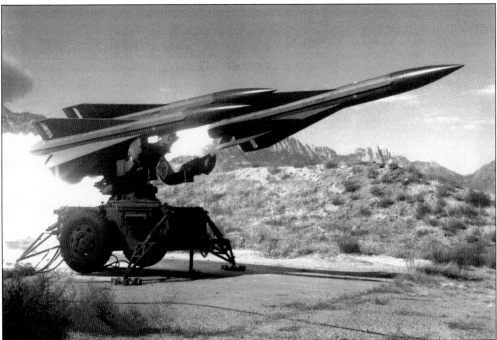

This Raytheon Hawk missile was first developed by Raytheon in the 1950s. Variants are still in service. (Courtesy Raytheon.)

This photograph shows the laser and optics of a subsystem developed by Waltham's Group 128 in the early 1970s for helping to transmit reconnaissance data from Vietnam to the United States. (Courtesy John Wood.)

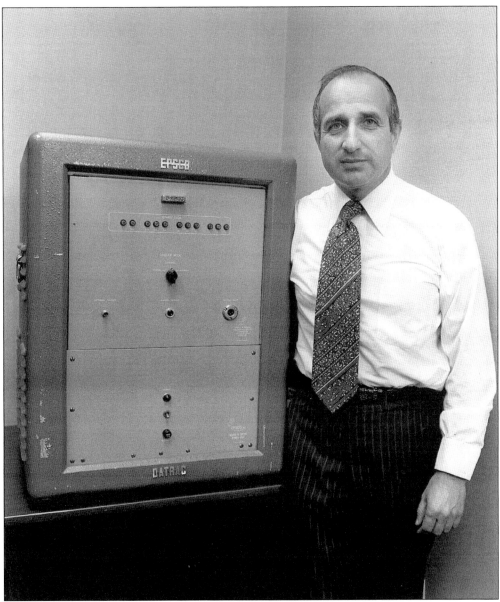

Shown here in the 1970s is Bernard Gordon, founder of Peabody-based Analogic, with a model of the world's first successive approximation, high-speed, analog-to-digital converter. In the early 1950s, Gordon and his associates developed A/D converters known as Datrac A and B. (Datrac B is shown.) The pioneering Datrac B units were implemented with approximately 100 vacuum tubes and made 50,000 measurements per second with 11-bit absolute accuracy. In the mid-1950s, thousands of these units were built and deployed in early computer-controlled manufacturing, and in missile and aircraft telemetry. Some notable developments, particularly in telephony digitization (Bells Labs), the first radar digitization (Lincoln Labs), and the first music digitization (EPSCO), were accomplished with this pioneering instrument. (Courtesy Analogic Corporation.)

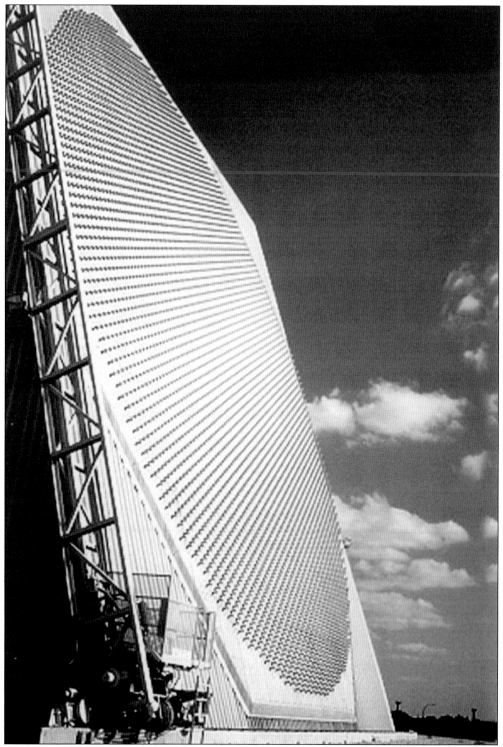

The BMEWS (Ballistic Missile Early Warning System) was a phased-array antenna for a radar system developed by Raytheon during the Cold War. (Courtesy Raytheon.)

This lunar ranging transmitter was designed to fire bursts of laser light at targets on the moon to achieve exact measurements of distances. The device was manufactured by Group 128, a Waltham maker of high-tech optical products. Its name was an attempt to cash in on the cachet of Route 128. The optical company also had a memorable address—Sun Street. Reginald Croughton is at the controls in this photograph from the early 1970s. (Courtesy Philip Lichtman.)

A 24-inch Cassegrain-type astronomical telescope at Group 128 is ready for shipment to an observatory c. 1973.

Ernst Milkovitz checks the curvature of large mirror at Group 128. (Courtesy John W. Wood.)

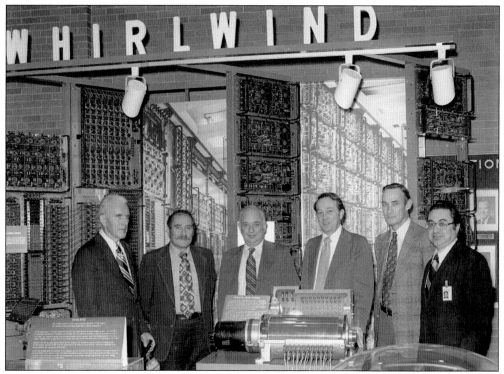

This is a gathering of alumni of the Whirlwind project at MITRE in 1977. They are, from left to right, John F. Jacobs, Alan J. Roberts, Robert R. Everett, Kenneth E. McVicar, John A. O'Brien, and Charles A. Zraket. (Courtesy MITRE Corporation.)

Three

A COMPANY CALLED DEC

Ken Olsen, a product of MIT and a veteran of the SAGE project, launched Digital Equipment Corporation (known to its old-timers as DEC, more commonly known as Digital) in 1957. Its growth became the yardstick against which other high-tech startups measured their success. The company grew rapidly and steadily into the 1980s on the strength of its minicomputers and later its computer disk business, services, and even (belatedly) personal computers. At its peak, the company employed more than 120,000 worldwide.

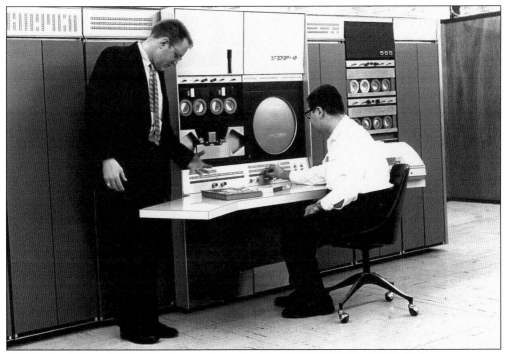

C. Gordon Bell and Alan Kotok are pictured with a Digital PDP-6—Digital's larger computer architecture. Twenty-three systems were sold globally. (Courtesy *Mass High Tech*.)

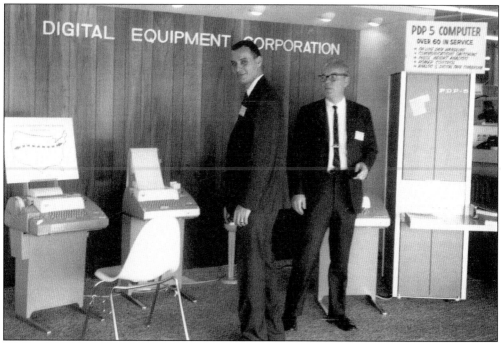

The best was yet to come when this Polaroid snapshot caught an early-1960s Digital trade show booth scene. Note the poster at the right, boasting that 60 PDP-5s were in service. (Courtesy Advanced Modular Solutions.)

This is the TIME SHARE-8, photographed in 1968. Digital's products, especially the PDP-8, became the cornerstones of this revolutionary technology, which permitted multiple users to share the use of a single computer. The author got his first exposure to programming via a time-shared PDP-8 at a suburban high school c. 1970. (Courtesy Advanced Modular Solutions.)

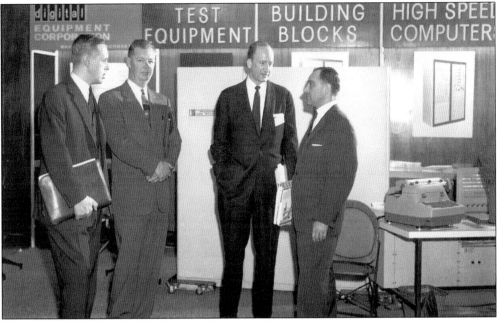

These well-heeled gentlemen at a Digital trade show booth in the 1960s do not look like revolutionaries. However, as purveyors of minicomputers, that is just what they were. (Courtesy Advanced Modular Solutions.)

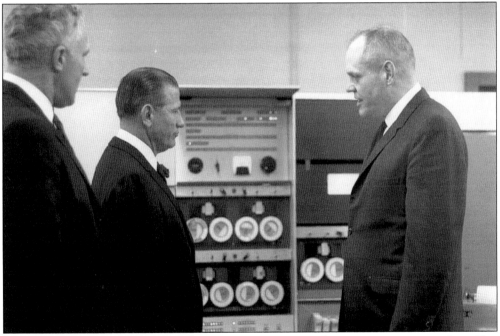

John A. Volpe, three-term Massachusetts governor, gets a lesson in computation from Ken Olsen. Volpe, later the second secretary of transportation (1969–1973), created the U.S. Department of Transportation "Transportation Systems Center" in Cambridge in 1970 when NASA withdrew from the area. He also promoted high-tech solutions to auto safety and air-traffic control issues.

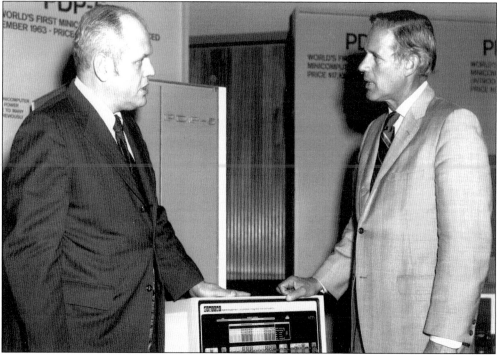

Ken Olsen is in conversation with Francis W. Sargent at an unidentified occasion, probably when the latter was Massachusetts lieutenant governor (1967–1969) or governor (1969–1975). (Courtesy Advanced Modular Solutions.)

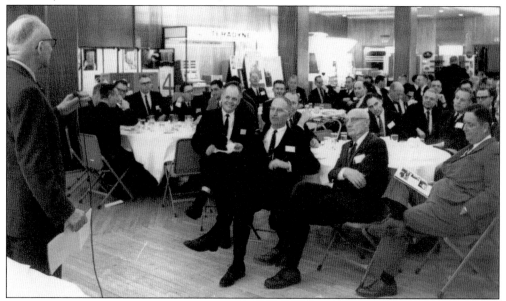

Gen. Georges Doriot, the founder of the pioneer venture capital firm American Research & Development (ARD), addresses attendees at the ARD annual meeting. Note the Teradyne display in the background. Teradyne, like Digital, was helped by funding and advice from Doriot. Olsen, smiling, is visible in the foreground, facing the speaker. (Courtesy Advanced Modular Solutions.)

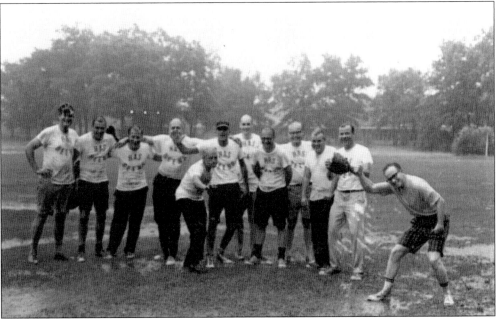

This softball game in the rain from *c*. 1970 features Ken Olsen and many other key figures from Digital. (Courtesy Advanced Modular Solutions.)

This is a photograph of DEC's Wall Street debut on December 1, 1970. Here, Ken Olsen (center) is welcomed to the New York Stock Exchange by president Robert W. Haack (left) and Mortimer Marcus, of Marcus & Company, specialist in the stock. Digital opened at 63. Even at this late date, computers were still suspect—the New York Stock Exchange identified Digital as a company that "designs, manufactures, sells, and services electronic products and equipment." Note the ticker symbol DEC just behind Olsen. (Courtesy Advanced Modular Solutions.)

For Digital, and for many other area companies over the years, going public was the ultimate milestone of success. In this image, Ken Olsen (center) watches for market reaction as the company makes its big-board debut. (Courtesy Advanced Modular Solutions.)

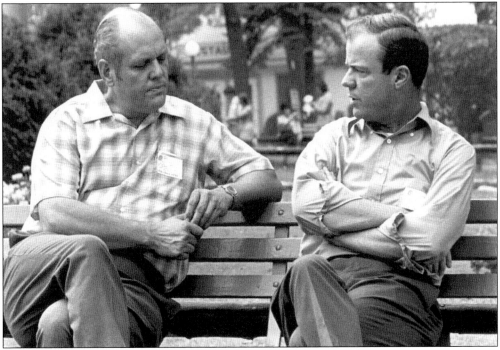

A snapshot from an October 1971 company outing catches Ken Olsen in conversation with Win Hindle, a longtime Digital executive. (Courtesy Advanced Modular Solutions.)

This photograph shows the assembly line for the PDP-11/05 at Digital's Maynard plant. First introduced in 1970, more than a million PDP-11s were eventually sold. Here, the 19th-century building's interior looks little different than it did as a woolen mill. Inhabitants of the "mill," as the building was always known within Digital, sometimes had to deal with residual lanolin, accumulated from decades of wool processing, dripping from the floorboards above. (Courtesy Advanced Modular Solutions.)

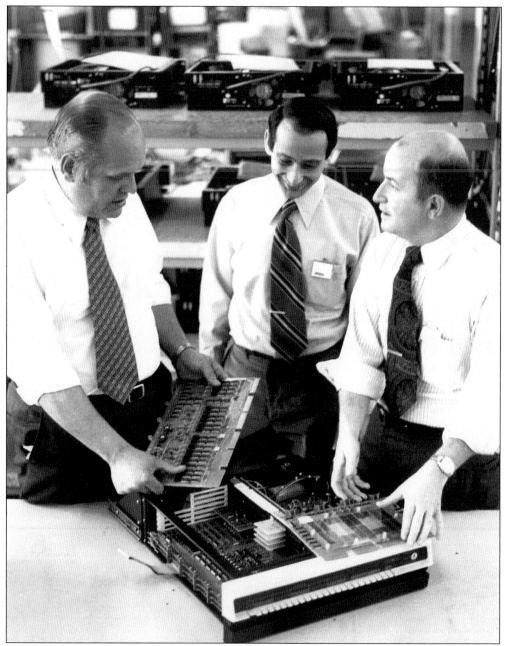

Ken Olsen and other executives check out products on the production line. Olsen was famous for his hands-on approach to engineering. (Courtesy Advanced Modular Solutions.)

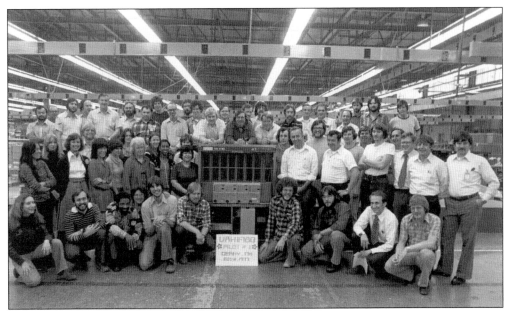

The first VAX prepares to move out of the assembly area at Derry, New Hampshire, on November 11, 1977. The VAX was such a hit that it sustained Digital's fortunes through the 1980s—insulating it for a time from the impact of the PC revolution. Its companion software, VMS (now called OpenVMS) still has numerous adherents and was reputed to be the inspiration for many of the features in Microsoft's Windows operating system. (Courtesy Advanced Modular Solutions.)

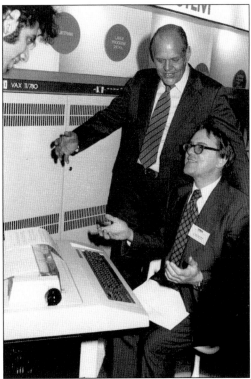

At the top of their game, Ken Olsen and C. Gordon Bell, a leader on the VAX/ VMS project, show off the new machine. (Courtesy Advanced Modular Solutions.)

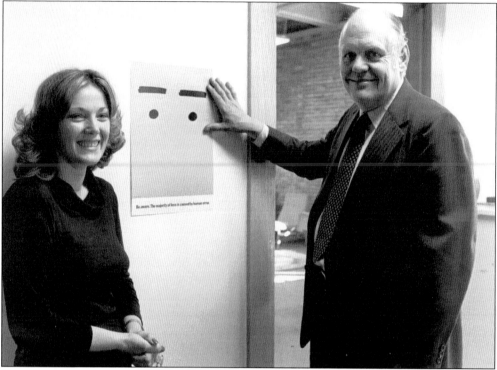

Ken Olsen and longtime assistant Ann Jenkins share a smile about an office poster in 1981, when Digital was the undisputed king of minicomputers. (Courtesy Advanced Modular Solutions.)

Pictured here is some of the engineering talent behind Digital's PCs. (Courtesy Advanced Modular Solutions.)

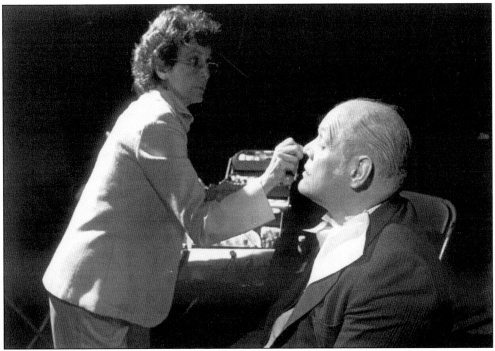

Although Ken Olsen was renowned for his folksy demeanor and concisely expressed opinions, this photograph shows that he could also play the role of media-savvy business leader. He is getting made up in preparation for a product introduction. (Courtesy Advanced Modular Solutions.)

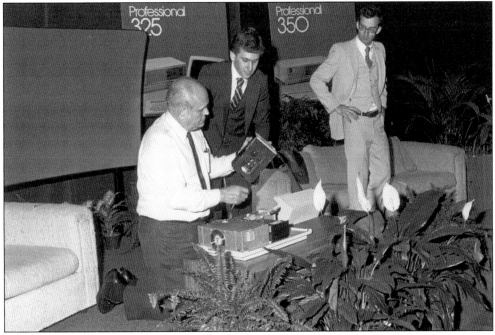

Olsen rolls up his sleeves, figuratively at least, at the May 1982 media event introducing the Rainbow 100, DECmate II, and DEC Professional Line (also known as DEC PRO), the company's response to the PC revolution. (Courtesy Advanced Modular Solutions.)

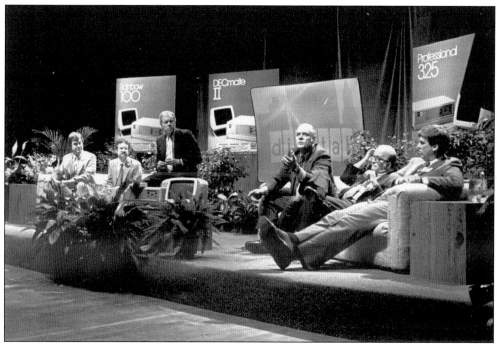

Potted plants and soft chairs must have been intended to position the new Digital PCs as a friendlier and more accessible kind of technology. Ken Olsen gestures in front of the projector screen. (Courtesy Advanced Modular Solutions.)

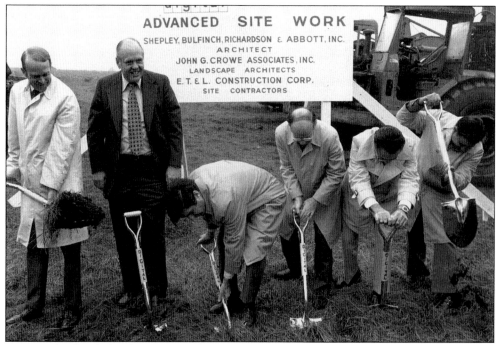

Gov. Michael Dukakis, bent over with shovel at the center, lends a hand at a groundbreaking for a new DEC facility, probably in the early- to mid-1980s, while Olsen looks on in a dark suit. (Courtesy Advanced Modular Solutions.)

Digital experimented with many ways of managing its relentless growth and constant change, including, most notably, matrix management, in which the traditional organization charts were replaced by numerous cross-functional responsibilities. For top managers, there were also the famous "woods meetings" to sort out strategy. Here, Ken Olsen and other key figures from Digital engage in a woods meeting in New Hampshire c. 1980. (Courtesy Advanced Modular Solutions.)

This is the Digital booth at the 1984 National Society of Professional Engineers 50th anniversary show in Kansas City, Missouri. Digital's mid-America district operations specialist, Deanna Michaelson, is shown here. To her right is Digital's Kansas City sales representative Steve Lemmon. Also shown is a representative of Tektronix Inc. Digital and the rest of the area's high-tech industry were responsible for a high percentage of flights in and out of the region's airports. (Courtesy Deanna Michaelson.)

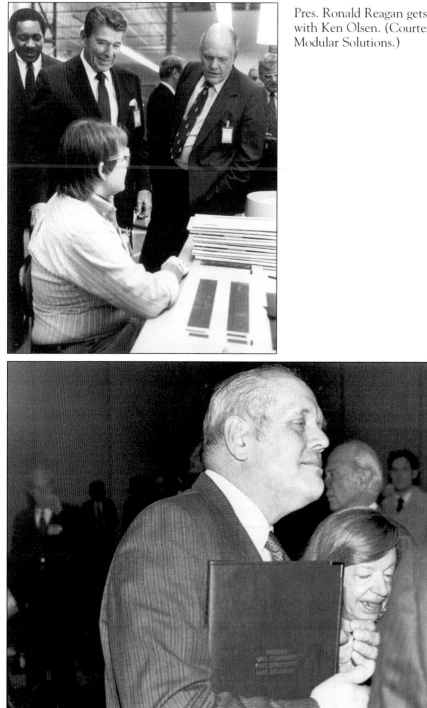

Pres. Ronald Reagan gets the mill tour with Ken Olsen. (Courtesy Advanced Modular Solutions.)

A confident-looking Olsen faces the crowd, probably at a mid-1980s annual meeting. The slogan on his binder says, "One Company, One Strategy, One Message," an optimistic response to criticism that the company had gone in too many directions and was in disarray. (Courtesy *Mass High Tech*.)

Four

THE MASSACHUSETTS MIRACLE

Although Digital led a parade of growing high-tech firms through the 1970s, the state experienced a peak unemployment of almost 12 percent in 1975. Also, the two oil crises (1973 and 1978) buffeted an economy that was still dependent on many older manufacturing firms. When high tech took off in the 1980s, impelled by increased defense spending, exploding demand for minicomputers and word processors, and other new technologies, the Bay State embraced the industry as its savior. The phenomenon, which got global attention as the Massachusetts Miracle, saw public policy interest in technology reach a new high. High tech, usually through the forum of the Massachusetts High Technology Council (MHTC), took an equally great interest in public policy.

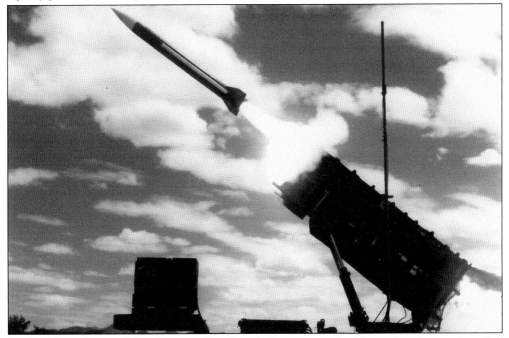

In the Massachusetts Miracle years, Raytheon's Patriot missile (shown here) went into full production, GTE built guidance systems for the MX missile, Avco-Textron produced missile components, Draper continued its work on guidance systems, Northrop built missile systems, and scores of other companies also benefited from both military procurement and research-and-development funding. (Courtesy Raytheon.)

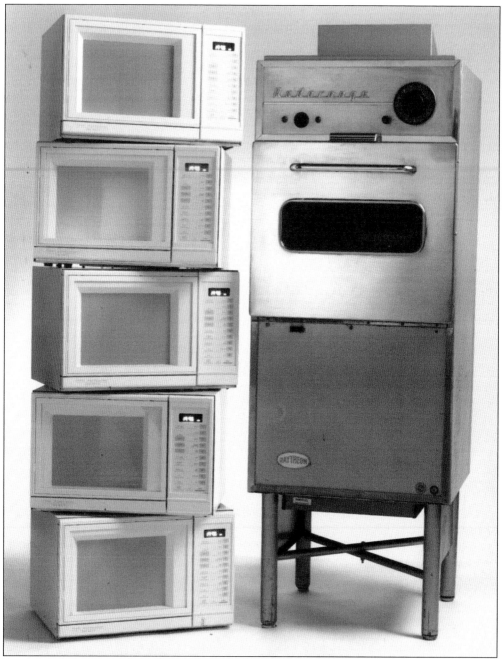

Raytheon also continued a pattern of building its countercyclical civilian businesses. The 1980s became the decade when microwave ovens—including the stack of new Amana (Raytheon) models shown here in contrast to a model from the 1940s—became part of every kitchen and many offices. (Courtesy Raytheon.)

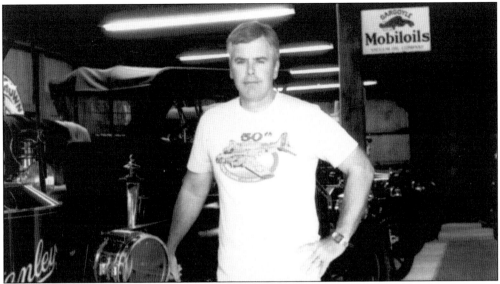

Bob Collings is shown amongst his collection of antique cars and aircraft. Collings made money with his Data Terminal Systems business—a pioneer in point-of-sale computerization in the 1970s. This photograph caught him at ease in the mid-1980s, when he was fully involved in the Collings Foundation, an organization that was founded in 1979 to support living history.

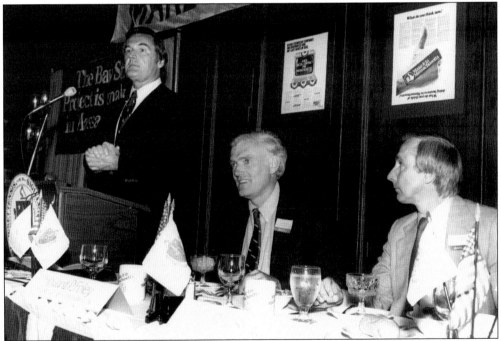

Gov. Ed King had a mutual admiration society with the Massachusetts High Tech Council (MHTC). His "Make it in Massachusetts" campaign tried to spur confidence in the local economy as well as investment from businesses. Here he addresses the council. To the right are Howard Foley, council president, and Ray Stata, of Analog Devices. Stata got wide visibility as a spokesman for high tech and the economy as coauthor of a book on American competitiveness called *Global Stakes*. (Courtesy MHTC.)

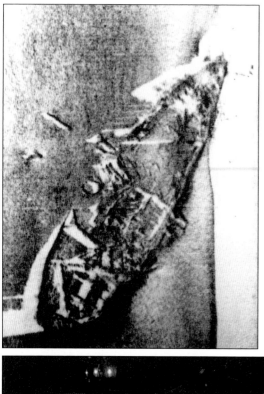

This 1980s side scan sonar image, taken by Klein Associates, shows the Vineyard Sound lightship, which was sunk on September 14, 1944, off the coast of Massachusetts. The water depth is 25 meters. Marty Klein was a protégé of MIT's Harold Edgerton.

Governor King's business-friendly style got rave reviews at this MHTC meeting. Note the photographer using Polaroid's famous SX-70 single lens reflex camera. (Courtesy MHTC.)

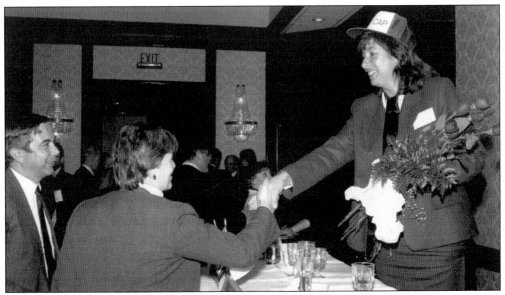

Barbara Anderson, of Citizens for Limited Taxation, wearing her "Tax Cap," gets roses and praise at a MHTC meeting. The effort led to the passage of Proposition 2½. (Courtesy MHTC.)

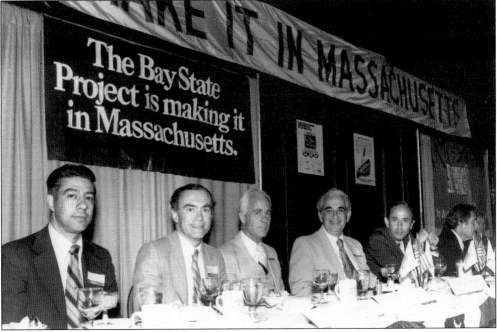

The MHTC helped shake up the political establishment in Massachusetts. Here are, from left to right, Carl Dantas of Compugraphic Inc., Edson D. deCastro of Data General, William Thurston of GenRad, George Kariotis of Alpha (and secretary of commerce in the King administration), Alex d'Arbeloff of Teradyne, Governor King (often an ally of the MHTC), and MHTC president Howard Foley. Note the "Make it in Massachusetts" banner, representing a major initiative of the King administration to encourage businesses to stay and grow in the state. It often provoked wry and ribald imitators, such as the contemporaneous bumper stickers that read "Naked in Massachusetts" or "Barely Making it in Massachusetts." (Courtesy MHTC.)

AnnaLee Saxenian probably never met Michael P. Belanger, who is pictured here. Saxenian's 1994 book *Regional Advantage: Culture and Competition in Silicon Valley and Route 128* painted a picture of dour, cubicle-bound New England techies unalive to the potentials for new deals and new possibilities all around them. Belanger, however, through the 1980s, launched and sustained an organization called the 128 Venture Group, which hosted packed monthly networking breakfasts for entrepreneurs, job seekers, and venture capitalists. At the time this photograph was taken, Belanger was vice president of marketing for software technology for Computers Inc. in Newton.

A highly visible icon of the new economy was Jonathan Rotenberg, chairman and founder of the Boston Computer Society (BCS). He is shown here with Tracy Licklider, president. Rotenberg started BCS in his early teens and soon attracted a large adult membership. Primarily oriented toward the emerging PC technology of the late 1970s and early 1980s, BCS was one of the largest and most powerful user groups in the world and helped attract a constant stream of vendors and their leaders to Boston—including Steve Jobs with the Macintosh and with Lisa, an ill-fated early Apple model.

Who is this man and why is he challenging the IBMpire?

Spartacus is on the move (p.5)

MASS HIGH TECH

VOLUME 1 — NUMBER 1 The newspaper for high tech professionals October 25, 1982

Job outlook OK so far

In a time of grim statistics, Massachusetts is holding on to one of the nation's lowest unemployment figures. The job picture remains strong so far in most of the high technology sector, with a number of hopeful signs.

Many high tech companies continue to post high profits and record sales. For example, Wang Laboratories' recent announcement of a 39 % rise in profits heartened area professionals.

The data-processing sector is robust, as software requirements proliferate. California-style recruitment deals, offering $1000 bonuses and an extra week with pay at Christmas, are being used to attract these valuable professionals. If you're an MIS professional, a programmer analyst, a software engineer, or a systems designer, you don't have to look for work. The computer manufacturers looking for you, as are systems manufacturers, process control houses, and other computer users.

At the same time, the employed segment of the work force is constantly looking for better opportunities. One small company, Plum Computer, recently placed two employment ads for software professionals, and was buried in responses.

The heavy volume of job activity has given rise to new computer-based services such as JobNet in Bedford, MA, which has set up data banks to encode and organized employment resumes according to a customer's specifications. This reduces the amount of time an employer must spend doing a "qualifications search" through large number of resumes.

Military contract awards remain strong in the Massachusetts area, with companies such as RCA, MITRE, Honeywell, GTE, and Raytheon involved in significant hiring programs, and competing via open houses for military communications engineers and other mil-spec specialists.

National signs continue to warn of the darker picture all around us. September saw another decline in the high tech recruitment index (HTRI) measured by the New York consulting firm of Deutsch, Shea, & Evans. (The HTRI measures the volume of recruitment advertising placed in professional journals and key newpapers each month.) On the basis of current advertising orders, DS&E projects a continued decline throughthe remainder of the year, with signs of an upturn beginning in 1983.

Another recent survey reported in this week's **US News and World Reports** give additional signs of commercial belt-tightening. One out of 4 firms is reported to be considering enacting freezes or delays in merit raises for 1983.

A study by the Hay Group found many companies using benefit trims, lower-than-predicted pay hikes, and salary cutbacks to control costs. More hiring bans, forced early retirement and layoffs are still being actively considered, they report.

Despite these nervous-making reports, no large-scale setbacks have surfaced to date in Massachusetts. The media have picked up news of a small cutback at Instrumentation Laboratories earlier in the season, which has recently been offset by increased sales and hiring. Similarly, a recent layoff

Continued to page 2

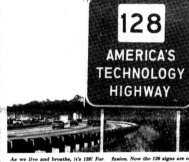

As we live and breathe, it's 128! For years the road was called either US 95 or 93, sending both out-of-towners and in-towners into endless circles of confusion. Now the 128 signs are coming back. These crisp blue-and-white panels are located near the Mass Pike in Newton.

Candidates focus on economy, business

by Alan R. Earls

Mike Dukakis has finally begun to square off with John Sears. After one of the lowest-profile campaigns in the state's history, he emerged last Tuesday for a gentlemanly bout in the hushed galleries of Boston's Federal Reserve Bank.

Dukakis repeatedly traced the state's economic woes to the devastating policies of Reaganomics, and held that the "national economy is crushing New England." Sears attacked the former governor's record on spending and industrial regulation, and reported that the Manchester Union-Leader had announced that Dukakis' election would be "the best news that New Hampshire could have."

Throughout the debate, each candidate played his role to perfection.

Dukakis suggested he has "mellowed...or at least tempered" his position since the more "confrontational" 70s. Despite repeated challenges by Sears, he remained self-composed. In his opening remarks, he moved swiftly over the main economic issues facing the Commonwealth: unemployment, competition with other tech states, from New Hampshire to Japan, taxes, health costs, energy, waste disposal, transportation. He singled out the need to prepared a work force for high-technology jobs, with "first rate schools,"that would emphasize subjects such as computer literacy. He reminded the assembled leaders he had "brought Massachusetts from the brink" in 75and vowed to make the state "a model for the nation."

Sears, in the more combative underdog role, came out swinging. "Today at last we get to meet the "new" Mike Dukakis. I feel like I'm looking at the unveiling of a new automobile. Has there really been a change in the model, or are the modifications cosmetic?...and what's the price tag?"

After attacking Dukakis for "giving business the business," he announced his priorities: cap state spending, provide property tax relief, cut savings tax, eliminate the "Dukakis surtax", and reduce the regulatory burden on industry. He would streamline government, he said, by "sunsetting unnecessary authorities." He would save money by computerizing medicaid

Continued to page 16

In the fall of 1982, the high-tech industry got its own voice-in-print—*Mass High Tech*, launched by entrepreneur Douglas Green. The author joined editor Joeth S. Barlas to help produce the first issue, shown here. In the 1990s, the title was acquired twice. After American City Business Journals bought *Mass High Tech* from City Media, it used *Mass High Tech* as a prototype for other regional journals. *Mass High Tech* was not the first business newspaper serving the region. An earlier periodical from the 1960s, called *128 World*, later was folded into a periodical called *Bay State Business* and faded out of existence in the early 1980s.

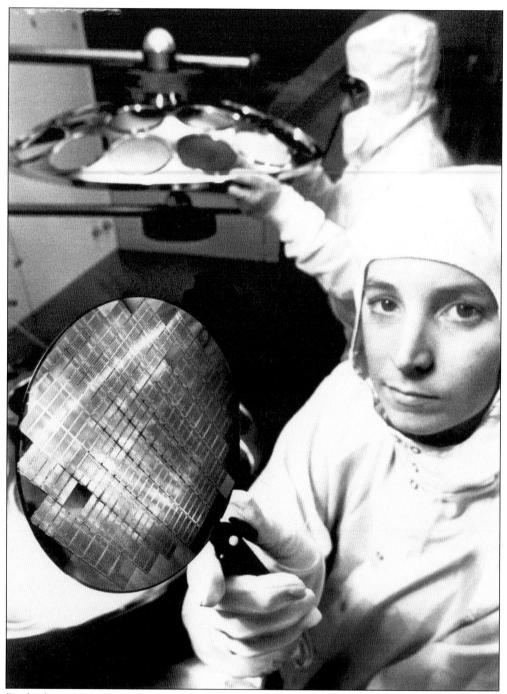

By the late 1970s, the clean room, essential to microelectronics manufacturing, had become a feature of many area companies. Here, a technician shows off a processed silicon wafer that will be cut into the components for dozens of chips. (Courtesy *Mass High Tech*.)

Spire, a high-tech company that made a name for itself commercializing solar panels, also was involved in semiconductors. Here, a closeup of a reaction chamber on Spire's MOCVD reactor shows gallium arsenide epitaxial layers being deposited. (Courtesy *Mass High Tech*.)

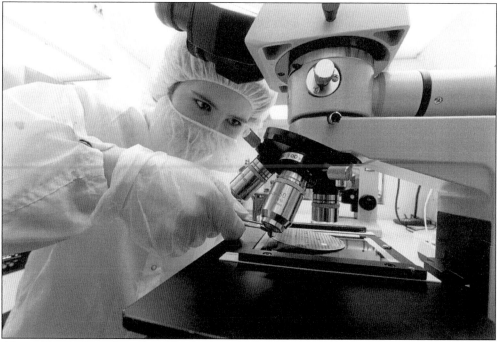

Alicia Bertrand, technical staff member at Raytheon Company's Research Division in Lexington, examines a three-inch gallium arsenide wafer for surface defects prior to processing. During processing, the wafer would again be inspected using laser-scanning microscopy. (Courtesy *Mass High Tech*.)

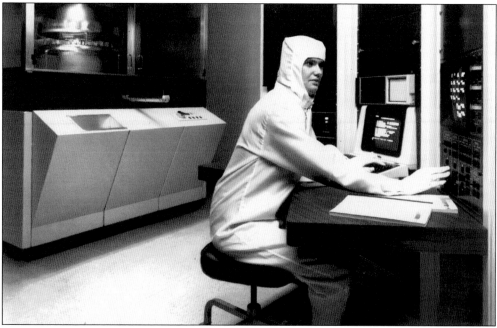

Ion Beam Technologies, in Beverly, was one of a cluster of companies on the northern end of Route 128—including Varian and Eaton—that provided tools of the semiconductor and integrated circuit trade. (Courtesy *Mass High Tech*.)

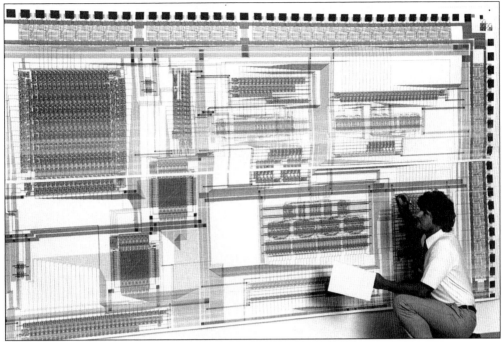

Stephen Delahunty, a Raytheon engineer, inspects the circuit connections on a computer-generated drawing of a microelectronic chip, enlarged 400 times. (Courtesy *Mass High Tech*.)

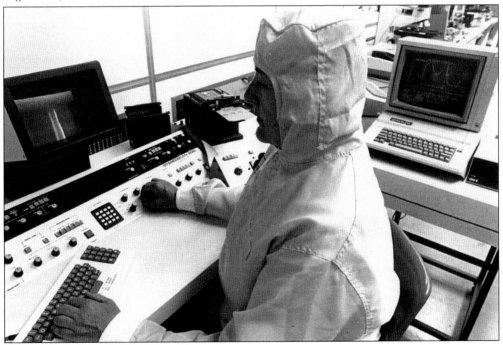

Ann De Bye, a Raytheon technician, uses an electron microscope that can magnify an object up to 200,000 times to make width measurements on circuit line connections in a microelectronic chip. (Courtesy *Mass High Tech*.)

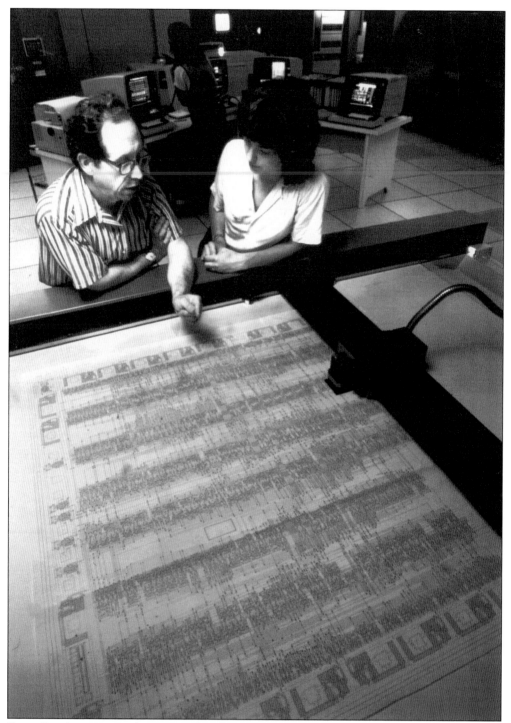

Susan Couch, a senior technician, and Paul Poppert, a senior member of the technical staff at GTE Laboratories, discuss the layout of a computer-aided design (CAD) very large scale integration (VLSI) circuit. GTE Lab was the successor to the Sylvania operation, which had been among the crop of area transistor pioneers in the 1950s and 1960s. (Courtesy *Mass High Tech*.)

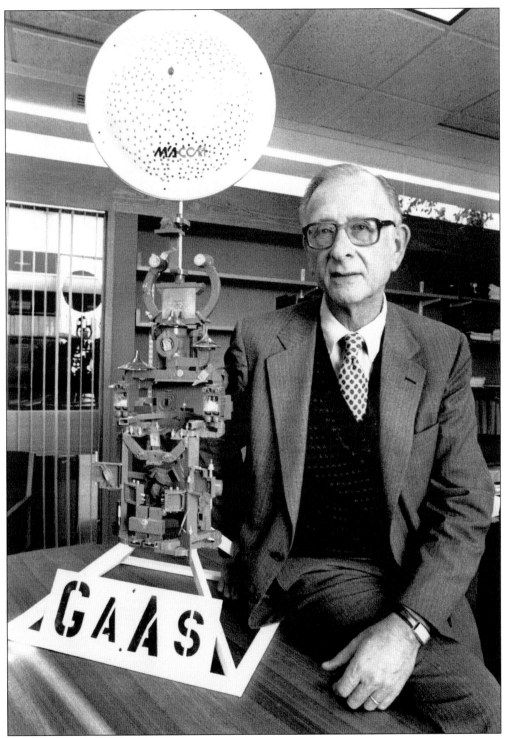

Dr. Joseph Saloom at M/A-COM is seen with an unusual-looking display that highlights the company's work with gallium arsenide semiconductors. (Courtesy *Mass High Tech*.)

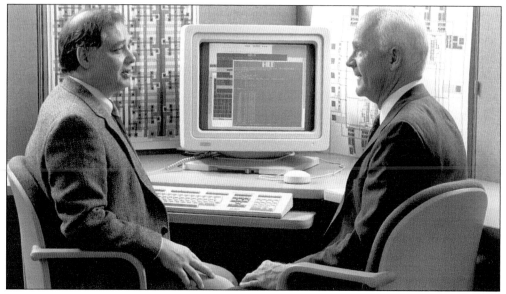

Arnold Ventresca, very large scale integration circuit (VLSI) and computer-aided design (CAD) operations manager at the Massachusetts Microelectronics Center (M2C) and William Thurston, chairman of the board of GenRad Inc. discuss M2C's acquisition of GenRad's HILO simulation system. M2C had a long history that began with hopes that with some government support, the state's high-tech companies could catch up with the leading lights of Silicon Valley. By the time the center finally hit its stride, there was no chance of fully catching up. However, the center went into the training business and helped support the area's colleges so that companies could at least grow some talent within the region. (Courtesy *Mass High Tech*.)

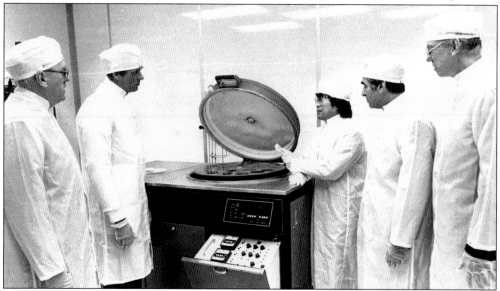

Dr. John C. Fan, founder and chairman of Kopin Corporation, explains how a plasma nitride system deposits insulating layers on semiconductor wafers. Kopin's new facility was in Taunton. From left to right are Donald C. MacLellan, assistant director of MIT's Lincoln Laboratory; Taunton mayor Richard Johnson; Dr. John C. Fan; Gov. Michael Dukakis; and Walter E. Morrow, director of MIT's Lincoln Laboratory. (Courtesy *Mass High Tech*.)

Milton Greenberg was chief executive officer of GCA, another company that was prominent in the wafer-processing industry until it ran into financial problems in the mid-1980s. (Courtesy *Mass High Tech.*)

Company president Paul van der Wansem discusses the operations of BTU's silicon-processing furnaces. BTU Engineering Corporation in Billerica was founded by MIT graduate J. Howard Beck in the 1960s. It was then, and continues to be, a leading international supplier of thermal processing systems for electronics, particularly silicon wafer processing.

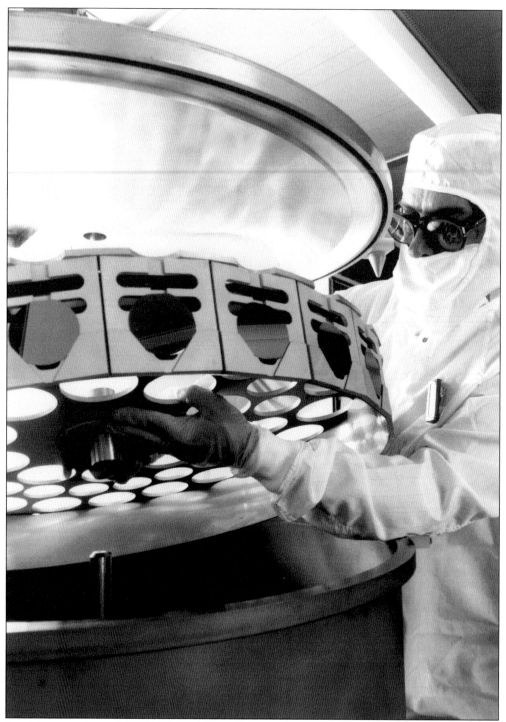

In addition to the well-known wafer labs run by Digital and Raytheon, Sanders Associates over the border in Nashua, New Hampshire, also invested in the technology. Here, a semiconductor specialist readies a carousel of gallium arsenide wafers for insertion into an ion implantation system at the microelectronics center. (Courtesy *Mass High Tech.*)

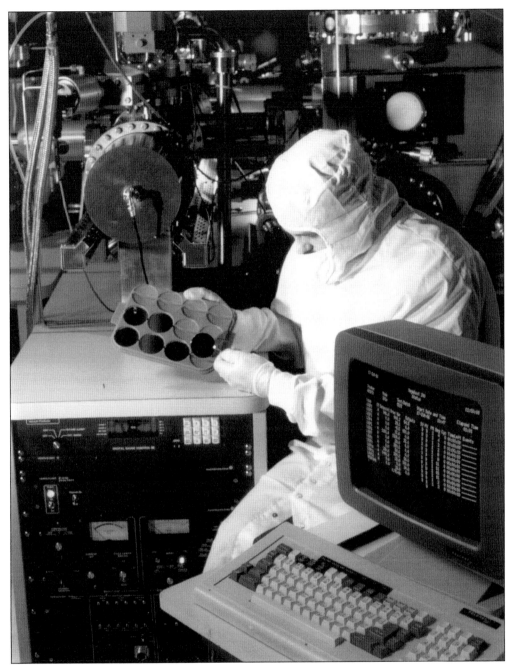

This is another view of wafer processing at Sanders. (Courtesy *Mass High Tech*.)

The boom in high tech put a strain on local convention and meeting facilities. Here, the old Hynes auditorium at Boston's Prudential Center prepares to host DECtown 1983, Digital's proprietary event that later expanded into the giant DECworld.

One answer to the need for more convention space was the proposed BOSCOM, which would have transformed the old Commonwealth Pier into the Boston computer marketplace. After further study, the plans were recast to turn the site into the present World Trade Center. (Courtesy *Mass High Tech*.)

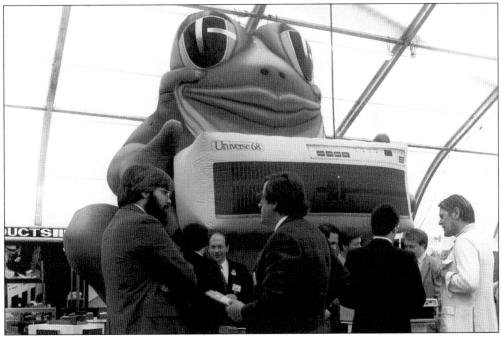

Charles River Data Systems, another company trying to ride the minicomputer wave, adopted a giant frog as a mascot. Their slogan was "leapfrogging the competition." Even as late as 1983, area startups still saw themselves as the next Digital. One, based near Lowell, developed a low-end minicomputer built on the Intel 8080, which also powered the IBM PC. They, however, used it as the CPU for a four-terminal system. Needless to say, Moore's Law, which promised to double chip power every 18 months, soon made it more compelling to simply buy a PC for everyone. (Courtesy *Mass High Tech*.)

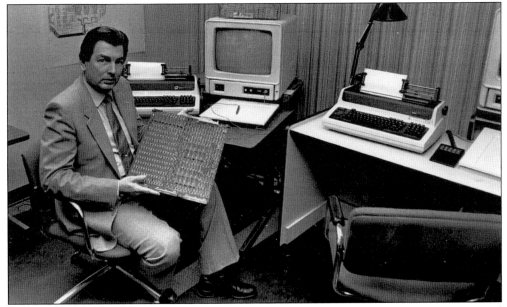

This is an executive of Triad Engineering in Burlington, one of the many vendors and subcontractors that supplied the top-tier high-tech firms. (Courtesy *Mass High Tech*.)

Wang Laboratories had a string of successes—pioneering electronic calculators, dominating the new market for word processors, and keeping a stake in minicomputers. Here, company founder Dr. An Wang addresses the MHTC. Wang was not particularly comfortable with public speaking in English, so such occasions were rare. (Courtesy MHTC.)

John Cunningham, a sales wizard who helped build Wang through the 1970s and early 1980s, was at one time assumed to be the heir apparent to lead Wang Laboratories. (Courtesy *Mass High Tech*.)

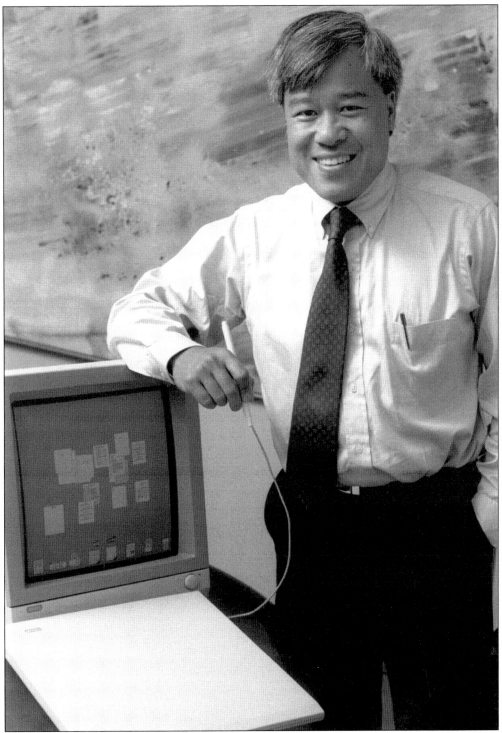

When John Cunningham found out that the heir apparent was in fact Wang's son Frederick, Cunningham's departure was swift. In this photograph, Frederick Wang is shown with the company's leading-edge interface technology.

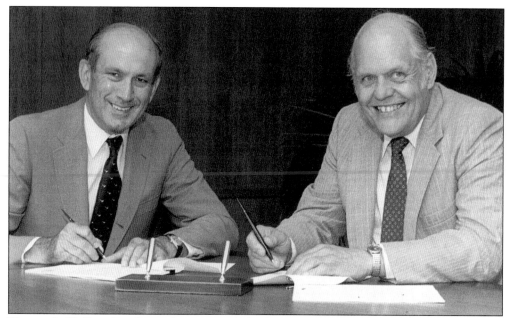

Thomas L. Phillips, Raytheon chairman and chief executive, and Ken Olsen, Digital president, sign a licensing agreement to combine technologies to produce an advanced military family of computers. Raytheon adapted Digital's VAX to meet military specifications. Raytheon had done some computer pioneering of its own with the Raydac line in the 1960s. Later, the firm made a foray into the word processing field with its Lexitron—a capable product that never caught on in large numbers. (Courtesy *Mass High Tech*.)

This is Kathleen Cote at Prime Computer. The face of high tech was increasingly feminized as more and more companies opened doors to women—or as women pried them open. Cote was one of the first women to make it into upper management in the region.

Kenneth G. Fisher was no longer in his Prime—Prime Computer, that is—in the mid-1980s when this photograph was snapped. He had left the presidency of Prime to colaunch Encore Computer Corporation with a group of high-tech executives. The company later moved to Florida, where Fisher was chair and chief executive officer. Thanks to Fisher's $2.5 million gift to the University of Chicago, from where he obtained his MBA in 1972, the school renamed its downtown Gleacher Center library the Kenneth G. Fisher Library in his honor. (Courtesy *Mass High Tech*.)

C. Gordon Bell, who had been vice president for engineering at Digital and proponent of the highly successful VAX, is shown here in 1984 in his role as chief technical officer for Encore Computer. He is delivering a keynote address at the DEXPO East '84, a trade show for DEC and DEC-compatible products. (Courtesy *Mass High Tech*.)

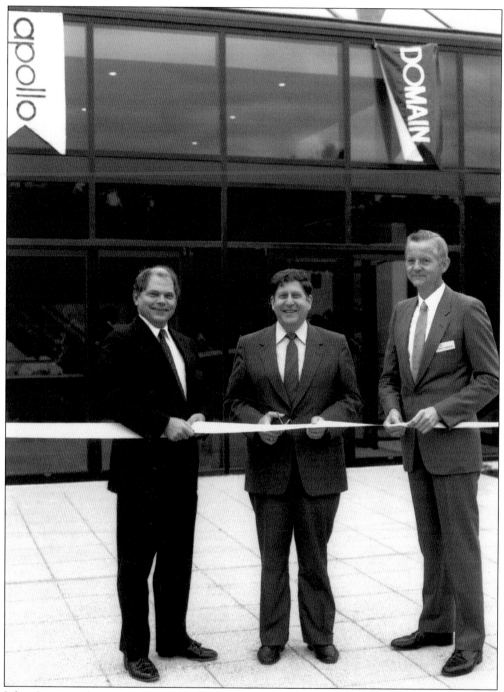

John Sununu, then New Hampshire's governor and later Ronald Reagan's chief of staff, is flanked by Apollo Computer founder John William Poduska (widely known as Bill) and Tom Vanderslice at the opening of an Apollo facility in New Hampshire. Vanderslice was talked away from his job as president of GTE to head the promising startup. A 1953 Boston College graduate, Vanderslice also spent time as chief executive officer of M/A-COM and in senior positions at General Electric. (Courtesy *Mass High Tech*.)

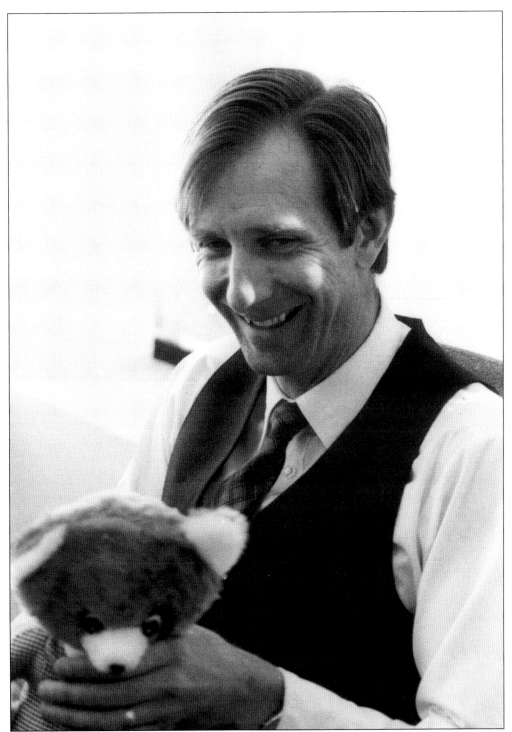

William Foster, chief executive officer of Stratus Computer—a Marlborough-based contender in the area of fault-tolerant technology—shares a moment of levity with the author *c.* 1985. Foster's talking executive teddy bear dispensed phrases such as "you are the greatest."

Before there was a biotech industry, there was Dr. Orrie Friedman, shown here in the mid-1980s. He founded Collaborative Research in 1961 and took the company public in 1982. The company published the first primary linkage map of the entire human genome and trained some of the future leaders of the area's biotech industry.

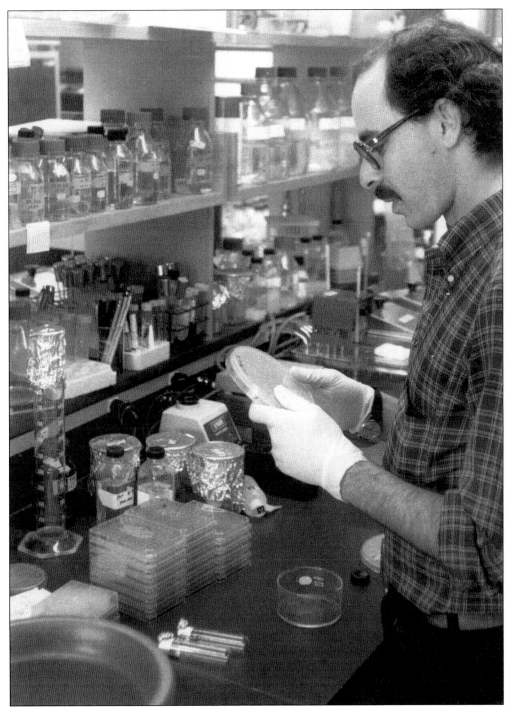

David Dash, a researcher at Biogen, is shown in the early 1980s. Biogen was the first big biotech company in the area and helped turn Cambridge into a hotspot. Harvard was also a crucial ingredient in this equation, since scientists Allan Maxam and Walter Gilbert there, along with Frederick Sanger of the United Kingdom Medical Research Council, had come up with a method for sequencing DNA in 1977. (Courtesy *Mass High Tech*.)

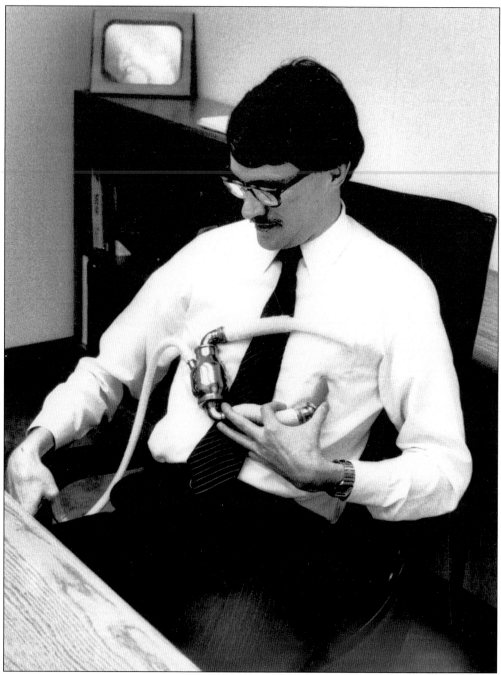

Since open-heart surgery was pioneered in Boston, it is not surprising that a number of local firms got into the cardiac-assist business. Here, in a 1985 photograph, John W. Wood, president of Thermedics—a Thermo-Electron spin-off—shows the approximate placement of one of the firm's LVADs (left ventricular assist devices). Thermedics was one of a large and growing number of area firms in the medical device market.

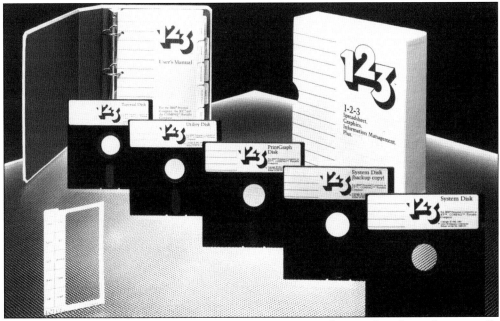

The original "killer app"—a computer application so compelling it forced people, especially business people, to run out and buy a computer—was made by Lotus. Lotus 1-2-3 was a spreadsheet program that permitted, indeed encouraged, a whole new level of analysis and planning. Knowing 1-2-3 became the quintessential 1980s business skill. (Courtesy *Mass High Tech*.)

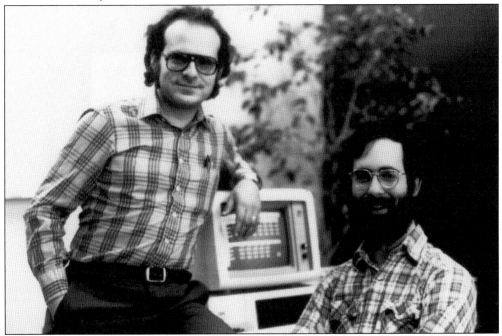

Bob Frankston and Dan Bricklin—president and chairman of the board of Software Arts, respectively—are shown in this photograph. Frankston also held positions at Lotus Development Corporation. Bricklin, another serial entrepreneur, later launched Software Garden and Trellix. (Courtesy *Mass High Tech*.)

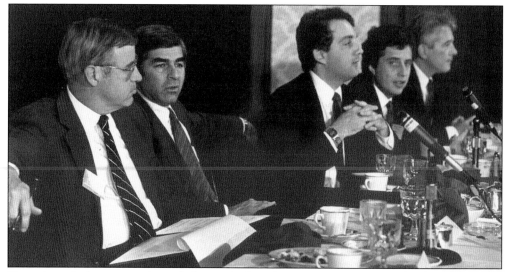

One sign of the maturation of the region's software companies was the launch of the Massachusetts Computer Software Council in 1985. Here, John Cullinane of Cullinet Software flanks Gov. Michael Dukakis. To the right of Dukakis is Mitch Kapor of Lotus Development Corporation, Richard Rabins of Alpha Software, and Steve Levine of TEC Computer Systems. Charter members of the group, which represented some of the top companies in the whole industry at the time, also included Eric E. Vogt of MicroMentor, William Bowman of Spinnaker Software, Daniel Bricklin of VisiCalc, Michael Kinkead of Saddlebrook Corporation, Dr. Julian Lange of Software Arts, Morton H. Rosenthal of Corporate Software, David Solomont of Business & Professional Software, Albert Vezza of Infocom, and Randall Wise of Graphics Communications. (Courtesy *Mass High Tech*.)

Frank Dodge was president and chief executive officer of McCormack & Dodge Corporation, which was founded in 1969 and produced accounting software. After many years of growth and independence, it was acquired by Dun & Bradstreet. Interestingly, Boston venture capitalists were the ones to fund most of the earliest software startups. (Courtesy *Mass High Tech*.)

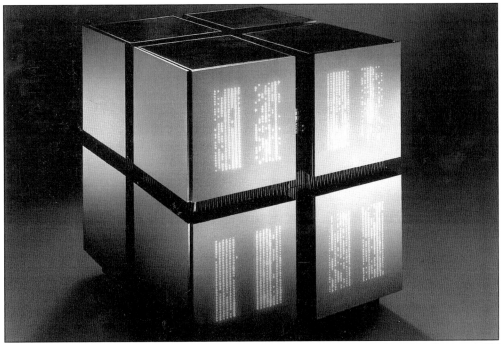

Thinking Machines—a company that came largely from the ideas of Dan Hillis, an MIT graduate student—managed to make the most high-tech-looking computer of all time. Inside, of course, it was, if anything, more impressive. Massively parallel, with thousands of processors, Thinking Machines generated excitement and helped legitimize the multiprocessor approach. (Courtesy *Mass High Tech*.)

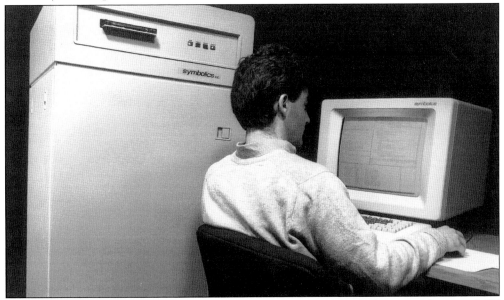

This is a Symbolics computer. Both Symbolics and LISP Machine had roots in the same MIT artificial intelligence research group. Their separation was fractious, with one group moving down the street to form Symbolics and the other decamping to Andover to launch LISP Machine. (Courtesy *Mass High Tech*.)

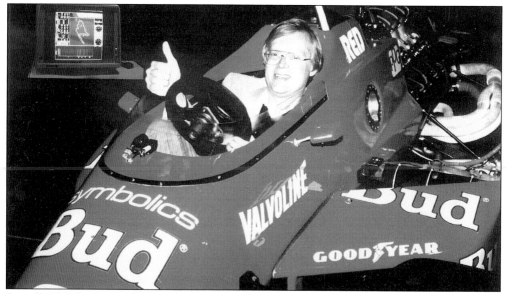

Russell Noftsker, president and chairman of Symbolics, one of the two largest artificial intelligence companies in the mid-1980s, squeezed behind the wheel of an Indy car slated for use on the CART circuit. In exchange for sponsorship recognition, Symbolics provided the TrueSports team with computer hardware and software designed to assist in analyzing data obtained directly from racecar sensors. (Courtesy *Mass High Tech*.)

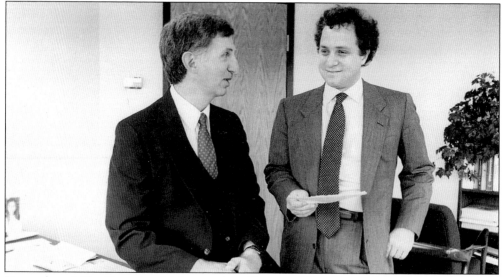

Pictured are Mike Tomasic, chief operating officer, and Ray Kurzweil, president of Kurzweil AI (artificial intelligence), which was one of several area companies to pursue this direction in computing in the mid-1980s. Kurzweil was a serial entrepreneur and inventor. He kept a collection of Edison memorabilia in his office, perhaps to underscore the scale of his ambition. His first big development, in the mid-1970s, was a reading machine for the blind subsequently acquired by Xerox. Stevie Wonder bought the first one, and it was introduced to the world on January 13, 1976, when Walter Cronkite closed the news by using it to say, "And that's the way it is." To invent the reading machine, Kurzweil pioneered many of today's computer technologies, such as the scanners found in many offices. (Courtesy *Mass High Tech*.)

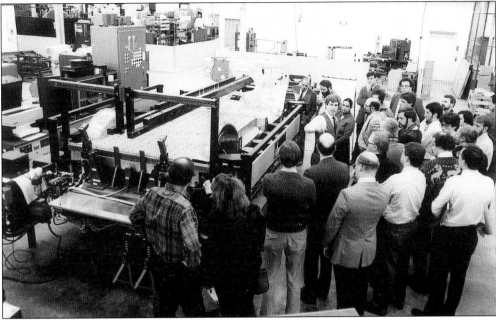

Pictured is a mid-1980s plant tour at Automatix in Billerica. At the time, the company was one of the most advanced in the area of robotics technology.

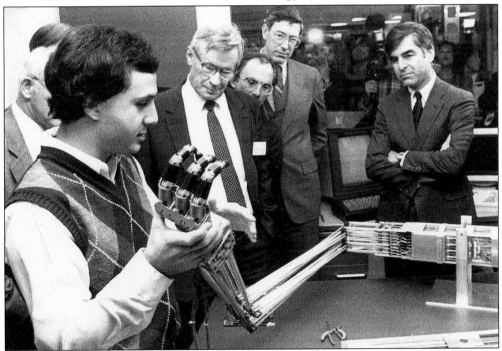

Gov. Michael Dukakis (right) and David S. Saxon, chairman of the MIT corporation, got a demonstration of a robotic hand from graduate student David M. Siegel during a gubernatorial visit in the mid-1980s to the artificial intelligence laboratory. The visit, which also included some high-tech executives, was part of a discussion of the state's economic future. (Courtesy *Mass High Tech*.)

119

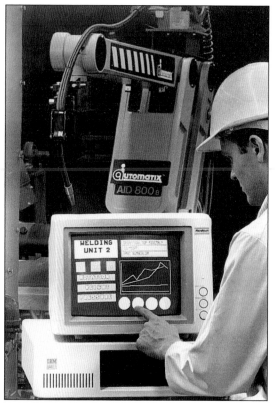

An Automatix industrial robot is getting shop floor directions from an IBM PC. Although now quietly integrated into all kinds of industries, the sudden influx of robotic technology into the workplace of the 1980s generated both interest and controversy at the time. (Courtesy *Mass High Tech*.)

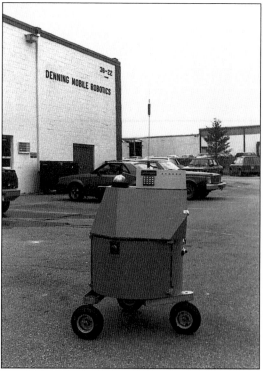

Even more unsettling than robots on the assembly line was Denning Mobile Robotics's Star Wars–like robot. Featured on the front page of the *Wall Street Journal*, Denning pitched the robots as, among other things, ideal supplements to human prison guards. Here, "Denny" takes a spin around the company's parking lot in Woburn in 1985.

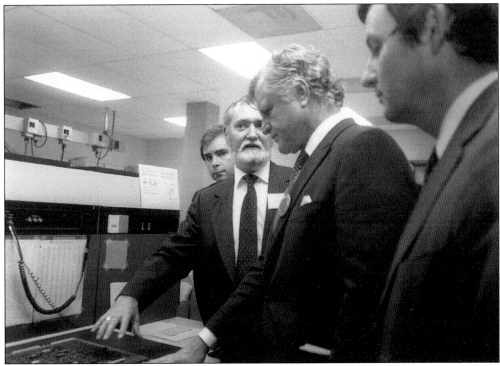

Sen. Edward Kennedy (center) goes face-to-face with artificial intelligence as he is escorted around the facilities of LISP Machine in Andover in 1986.

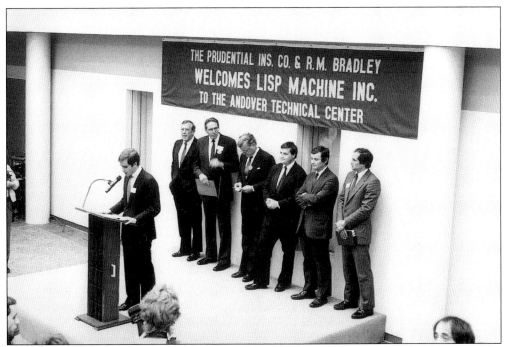

Kennedy and 5th Congressional District Rep. Chet Atkins are pictured at the LISP Machine open house.

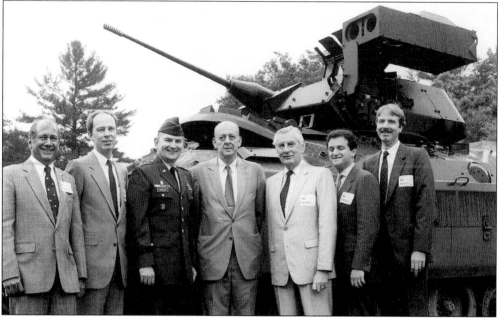

Executives of Bomar pose with army officials and a Bradley Fighting Vehicle at the company's offices in Acton in the mid-1980s. Bomar had achieved fame with its calculator called the Bomar Brain and, by the 1980s, was also involved in defense electronics.

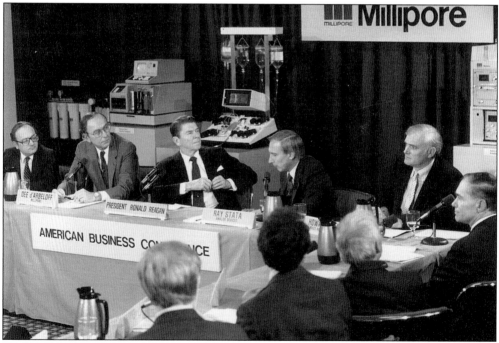

In this January 1983 photograph, members of the MHTC hosted Pres. Ronald Reagan at Millipore in Bedford, Massachusetts. Second from the left is Millipore president Dee d'Arbeloff, brother of Teradyne cofounder Alex d'Arbeloff. To the right of Reagan is Ray Stata, founder of Analog Devices, and MHTC president Howard Foley. (Courtesy *Mass High Tech.*)

In this 1985 photograph, Sen. Paul Tsongas points to the location of the planned Wang Laboratories education center (now home to Middlesex Community College). Tsongas and other local leaders had taken Lowell—a run-down mill city—and brought it back to life. Part of the formula was good local leadership and the skillful use of federal grant money. The influx of high tech, especially Wang Laboratories, was also critical.

So successful was the Massachusetts Miracle and so particularly spectacular was Lowell's comeback that Charles, Prince of Wales, paid a visit in 1985 to see what ideas could be applied in Britain's old industrial towns. (Courtesy National Historical Park Library.)

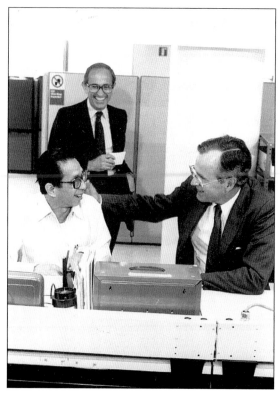

Vice Pres. George H.W. Bush chats with a worker at Teradyne in Boston while company president Alex d'Arbeloff looks on.

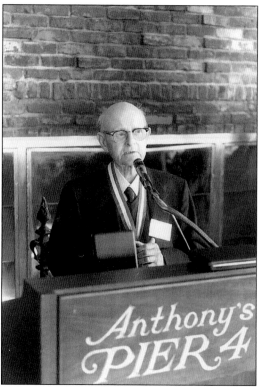

The state scored three wins on this day in 1985 when the Inventor's Hall of Fame held its induction ceremony regionally at Anthony's Pier 4 Restaurant. Inductees included avionics pioneer Andrew Alford (shown here), MIT's Jay Forrester, and Edwin Land of Polaroid. Although little known, Alford's work, pursued from offices in a small Route 128–area industrial park, was critical to development of LORAN and other forms of aircraft navigation and control.

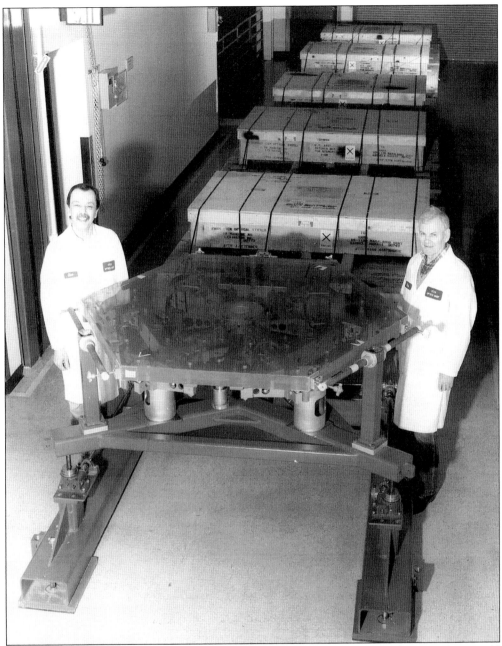

In this late-1980s photograph, 6 of the 36 polished mirror segments can be seen that would eventually make up the W.M. Keck Observatory telescope at Mauna Kea in Hawaii. Litton's Itek Optical Systems Division in Lexington employed a new technique called stressed mirror polishing, which let each mirror focus light to the same point. Itek had many triumphs using optical technology. They were largely responsible for the development of the 1960 Corona Satellite, the world's first spy satellite, and the later series of "key hole" satellites, which made the Soviet Union and much of the rest of the world an open book to U.S. government analysts. (Courtesy *Mass High Tech*.)

Workers install a vault that will contain electronic equipment associated with New England Telephone's fiberoptic telephone system at the Centennial Park in Peabody in this 1985 view. The vault contains space for workers to check and maintain equipment. (Courtesy *Mass High Tech.*)

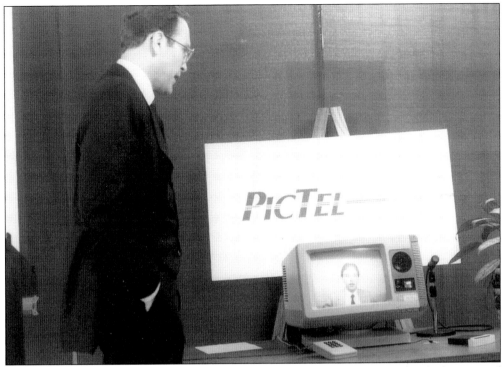

PictureTel revived the combined telephone and television camera idea that had generated excitement in the 1964 World's Fair and made it practical. PictureTel's focus ended up on videoconferencing, however, rather than on consumer applications. (Courtesy *Mass High Tech*.)

Racal-Interlan evidently had something special to celebrate in this 1989 image. Located along Interstate 495, the company was involved with data communications technology. (Courtesy *Mass High Tech*.)

The Stouffer's High Tech 10k Road Race—another sign that high tech had arrived—became a tradition for the region's runners in the 1980s.